To CARRIE,

THANKS SO MUCH FOR ALL YOUR EFFORTS TOWARD THE FLARE SURVEY. I AM SORRY I HAVE NOT CONVINCED YOU TO PRUSUE A LIFE OF PICTURE FLARES.. BUT WISH YOU ALL THE BEST

JUNE '04

Andy

Ashmolean handbooks

Frames and framings

in the Ashmolean Museum

Timothy Newbery

Published with the aid of a
generous grant
from Hall and Knight Ltd

Ashmolean Museum Oxford
2002

Text and illustrations © the University of Oxford:
Ashmolean Museum, Oxford 2002
All rights reserved
Timothy Newbery has asserted the moral right to be
identified as the author of this work
ISBN 1 85444 174 4 (paperback)
ISBN 1 85444 175 2 (papercased)

Titles in this series include:
The Ashmolean Museum
Drawings by Michelangelo and Raphael
Ruskin's drawings
Samuel Palmer
J.M.W. Turner
Camille Pissarro and his family
French drawings and watercolours
Oxford and the Pre-Raphaelites
Twentieth century paintings
Miniatures
English Delftware
Worcester porcelain
Eighteenth-century French porcelain
Maiolica
Islamic ceramics
Indian paintings from Oxford collections
Ancient Greek pottery
Glass of four millennia
Finger rings from ancient to modern
Scythian and Thracian antiquities

British Library Cataloguing in Publication Data
A catalogue record for this book is available from the
British Library

Cover illustration: Paolo de Matteis, *The Choice of Hercules*,
no.18 (detail)

Designed and typeset in Versailles by Roy Cole, Wells
Printed and bound in China by Midas Printing International Ltd.
for Compass Press Ltd.

Introduction

The idea of the picture frame existed long before
actual frames were carved from wood. Narrative
and figurative images in mosaics and wall-paintings
were often given decorative borders in early Christ-
ian and medieval churches. Byzantine and medieval
book-covers and caskets incorporated borders and
framing devices around relief images. Portable or
free-standing pictures were given frames partly for
the same aesthetic reasons of accentuating an
image, enhancing its colours and appearance, and
separating the imaginary world of the image from
the reality of its surroundings. However, practical
problems of handling and moving made it necessary
that frames should also be protective.

Frames for pictures (and mirrors) are related
to furniture in a number of ways: they have a func-
tion; the skills of cabinetmakers and joiners were
employed in their making; the decorative motifs in
some French and English frames derive from the
mouldings of wall-panelling. Moreover frames were
sometimes designed to match the overall décor of a
room, including the ornamental details of furniture
and of door or window mouldings. As an applied
art, frame-making is closely linked to the work of sil-
versmiths and goldsmiths. While the protective
function of a frame may determine its structure,
there is great potential for inventiveness in its deco-
ration. The collection of frames in the Ashmolean
Museum provides a variety of examples of European
frames that broadly illustrate the ways in which the
picture-frame developed over the centuries.

The earliest frames in the Ashmolean come
from thirteenth-century Tuscany, when wooden
panels usually of poplar, were used as supports for

painting. At first, the centres of small panels were chiselled out, leaving a raised lip all around to provide a protective border, maintaining the frame and painting as one object. Subsequently, simple mouldings were glued and nailed around the edge of a panel to carry out the same function: these frames were *engaged*, meaning that they were permanently fixed (see nos.1–3). With larger paintings or complex *altarpieces* made of many panels, planks of wood were joined with glue and dowels, and mouldings sometimes concealed the joins. The *Crucifix* by the Master of Saint Francis of 1280 in the National Gallery (NG 6361) for example shows a panel built up of planks in the form of a cross.

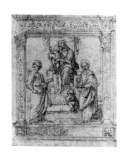

Complex altarpieces, with their gables, pinnacles, finials and carved tracery, deliberately reflected architectural forms, emulating the façades or cross-sections of Gothic churches. With a growing interest in illusionism in art, frames became more complicated so as to enhance painted compositions, while sometimes participating in illusionistic effects. The small altarpiece of *The Crucifixion* by Jacopo di Cione (and workshop) of *c*.1368 in the National Gallery (NG 1468), illustrates how frames began to develop a Gothic architectural appearance with pointed arches. On a smaller scale, the gabled panel by Andrea Vanni (no.3) likewise reflects Gothic architectural motifs. Frames were sometimes deliberately used to increase the sense of illusionism in a painting, as in *The Crucifixion* by Francesco di Vannuccio of 1380 in the Gemäldegalerie, Berlin (inv.1062B) where the painted forms of the landscape and crucifix overflow onto the frame itself.

Aedicular frames first appeared in Florence in about 1470. They were based on classical architecture which was rectilinear in construction, and their decorative motifs were adapted from architectural prototypes. (fig.1) The developing taste for antique forms in architecture and the applied arts influenced the way frames were made. An aesthetic separation began between paintings and frames, with panels loosely fitted into a rectilinear surround rather than

Fig.1: Probably by Boccaccio Boccaccino (before 1466–1525) *Design for an altarpiece showing alternative treatments of the frame decoration* Pen and brown ink Ashmolean Museum, purchased WA1936.186

being part of the same structure. A fine example of
an aedicular frame may be seen on *The Madonna
della Rondine* by Carlo Crivelli of *c*.1490 in the
National Gallery (NG 724). At this time canvas
began to be used as a cheap, lightweight and flexi-
ble support for painting, but evidence survives to
show that on occasions canvas was stretched over
panels, using the *back frame* of the frame as a
stretcher. By the later sixteenth century canvas was
the most common painting support in Italy.

In Flanders engaged frames had been made in
a slightly different way, probably because oak was
used. It is a stronger and finer-grained wood than
poplar and this led to thinner and sharper mould-
ings which were pegged together. Later, more com-
plicated methods of construction were developed,
with differences of proportion between mouldings.
One of the finest early examples is on *A Man in a
Turban* by Jan Van Eyck of 1433 in the National Gal-
lery (NG 222). By contrast with Italy, framing in
Flanders continued to remain close to painting until
the late sixteenth century: engaged frames were still
in use, and oak panels provided a support.

In sixteenth-century Italy, picture frames were
often carved by sculptors who wanted to display
their virtuosity: inventiveness and individual skill
were now highly prized. One style of frame named
after the architect and sculptor Jacopo Sansovino
(1486–1570) enjoyed international popularity in the
mid and late sixteenth century. The decorative
motifs of the Sansovino frame derived from a vari-
ety of sources, including the experiments with archi-
tectural decoration of Michelangelo (1475–1564) and
Giulio Romano (?1499–1546), the stuccowork of Tus-
can and Emilian artists at the court of Fontainebleau
in France, and the designs for the stucco and carved
ceilings by Alessandro Vittoria (1525–1608) and his
circle in Venice. Walnut was frequently used, for
example in the frame of *c*.1570 on *The Entombment*
by Michelangelo of *c*.1500 in the National Gallery
(NG 790). In Spain, engaged *reredos* in the Gothic
style continued to be built until the middle of the six-

teenth century, when the 'New Antique Aedicular' style arrived, and classical forms were used, as in the high altar of the basilica at the Escorial.

While important altarpieces still had great influence on the wider practice of frame making, by the end of the sixteenth century in Italy it was common for wealthy collectors to order sets of frames to show off and unify groups of paintings hanging in their princely galleries. These became known as gallery frames and were usually in styles particular to each collector. To make these, and to allow pictures to hang close together, construction was simplified and consequently the *cassetta*, a box-like structure, was a preferred type until the middle of the seventeenth century (see no.4). For example when Cardinal Cesare Monti framed his collection of contemporary Milanese paintings and drawings around 1635–50 he chose to use gilt or *ebonised* pearwood *cassette*. These were based on frames in the collection of Cardinal Carlo Borromeo which can still be seen in the Ambrosiana, Milan. From the late seventeenth century other mouldings were used for gallery frames, including hollows, *ogees* and, more influentially, the Salvator Rosa and Carlo Maratta patterns (see nos. 19 & 28). In Rome, paintings bought for princely collections such as those of the Colonna, Doria Pamphili and Spada families were reframed in this style to hang in the family palazzi.

In France, frames made in the early seventeenth century were influenced by Italian baroque architectural mouldings used in interior decoration. By 1660 a distinctive style of ornament had been established under the auspices of Charles le Brun (1619–90), who was charged by Louis XIV with developing the arts in France so as to reflect the glory of the monarch. From this date mouldings, carving, embellishments and gilding became more precise and orderly, particularly around Paris where court taste was focused (see no.15).

In Holland many more frames than before were made in the seventeenth century because of

6

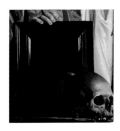

Ebony Mirror

the increased production of small-scale pictures for
the homes of a growing merchant class. Until
*c.*1650, these were mostly plain ebony or ebonised
pearwood frames: after this date, gilt *auricular* and
Louis XIV styles were also produced (see nos.12 &
14). Ebony was initially imported by shipping com-
panies as saleable ballast when returning through
the tropics, and this rare wood was sparingly used
as a veneer. An early example of an ebonised frame
can be seen in the *Allegory of Vanity* of *c.*1620 by an
artist perhaps from Utrecht. (fig.2) Black and brown
polished frames are often seen in the interiors paint-
ed by Vermeer, Metsu and de Hooch, where they
hang on white or light-coloured walls, in sparingly
decorated rooms with dark turned-wood furniture.

In England frames were influenced mostly by
Netherlandish models until the mid seventeenth
century, generally being made of oak and painted
black. However, there was also a very important
Italian influence, with Sansovino-style frames
amongst other styles becoming fashionable around
the 1630s. This came probably with the purchase of
the celebrated Gonzaga Collection in 1627 by
Charles I and with the collecting activities of promi-
nent noblemen like Thomas Howard, Earl of Arun-
del. After the restoration of the monarchy in 1660
new Italian and French styles began to dominate.
One type can be seen at Althorp, where the pictures
of Robert Spencer, second Earl of Sunderland
(1640–1702), are framed in a style that historians
have called Sunderland frames. Known to contem-
poraries as 'leatherwork' frames, these complex
carved and gilded frames, full of rhythm and sculp-
tural energy, incorporate stylised animal and marine
motifs.

From the beginning of the eighteenth century,
French frame design influenced many European
patterns with particular mouldings and ornament.
Frames were carved, decorated and water-gilt to a
level of refinement which often surpassed that of the
paintings they enclosed. The level of sophistication
found, for example, in the reframing of *The Adora-*

7

tion of the Golden Calf by Nicholas Poussin of
c.1633–34 in the National Gallery (NG 5597) – the
frame was made in Paris about 1720–25 for the Duc
d'Orleans – could only have been achieved after
many years of highly organised workshop practice.
A fine example in the Ashmolean is discussed later
(no.16). In the Galleria Sabauda, Turin, there sur-
vives a collection of Louis XIV-derived frames.
These were ordered by Prince Eugene of Savoy in
Vienna after 1714 for his Flemish sixteenth- and sev-
enteenth-century paintings. Forty years later, over
six hundred frames were commissioned by Freder-
ick-Augustus II in a French-derived rococo style for
his collection of old master paintings, many of
which can be seen in the Staatliche Kunstsammlun-
gen, Dresden.

In the early eighteenth century, Rome and
Venice re-emerged as centres of framing inventive-
ness, with large collections of paintings reframed by
their owners, while Grand Tourists imported new
styles of frame to the north of Europe. The name of
the artist Carlo Maratta (1625–1713) is associated in
England with a particular design which takes its
pattern from an Italian frame type first used in
Naples by the painter Salvator Rosa (1615–73) (see
nos. 19 & 28). This design had a versatility and clas-
sicism which was highly influential in England. In
Venice, the influence of Louis XIV mouldings can be
seen in *Canaletto* frames: their typical raised *ogee*
moulding was the fundamental element of early
eighteenth-century ornament. An interesting exam-
ple of a Canaletto frame in an English Grand Tour
collection may be seen on a pair of landscapes by
Francesco Zuccarelli (1702–88) at Stourhead, Wilt-
shire (National Trust) where the extending ornament
has been replaced in England in the 1790s.

In the late eighteenth century Greek classical
ornament influenced the styles of picture frames.
James 'Athenian' Stuart, Robert Adam and William
Chambers introduced these elements into English
architecture and interior design, producing a monu-
mental style with very precise antiquarian detail.

8

Benjamin West drew on this inspiration to frame his paintings: for example his *St Paul shaking a Viper from his hand* of 1789 in the Royal Naval Hospital, Greenwich, London, has a frame carved with patterns copied from the Erechtheum, Athens.

The development of frame ornament made with *composition* from the later eighteenth century was quite different from that of carved frames. Carved frames were designed as a whole, with adjustments made to the proportions throughout. Composition, by contrast, is a mouldable material made of whiting, glue, oil and resin. Long runs of ornament were made from moulds, so that ornament could be applied to frames cheaply, being ordered from catalogues by the middle-class collector. The easy application of readymade decorative motifs did not encourage integrated designs. An example of this is the original frame on *Calais Pier: An English Packet arriving* by J.M.W.Turner of 1803 in the National Gallery (NG 472). Here a Morland-style frame has had a composition acanthus leaf added in the hollow, ornamenting a moulding which is not visually strong enough to take this addition. Heavily-decorated, showy frames were popular in the public exhibitions of the Royal Academy and of the Salon in Paris, moreover an increasing awareness of the history of ornament led to a variety of 'revival' styles (see nos. 27 & 29). Various groups of artists in the second half of the nineteenth century reacted strongly against this approach.

The Pre-Raphaelite Brotherhood of artists resisted the use of mass-produced, detailed ornament and drew their inspiration from thirteenth- and fourteenth-century Italian mouldings which to their eyes were simpler and less pretentious. They designed frames that were crisply *gessoed* with water-gilt mouldings and sparse ornament, sometimes applied (see nos.24 & 25). Elsewhere they preferred oil gilding directly on oak which suggested an honest, craftsmanlike approach. This response was seen across Europe, with influential artists such as Whistler and Degas designing their own frames.

Despite this, most frames remained highly ornate until the early twentieth century, when the larger, versatile workshops began to disappear. Artists increasingly re-used old frames or embellished simple, readymade mouldings to create their own styles. With the advent of modernism, many artists rejected the picture frame, because it was associated with illusionistic painting or with the traditional values of high art. In some museums around the mid-twentieth century, period frames were removed from both modern and old master pictures because they were viewed as interfering with the integrity of the picture.

Very few pictures today are seen in their original frames, because frames have so often been linked to interior decoration and to changing tastes. Owners have wished to assert their own values and interests through re-framing the paintings in their collections. In museums today, the question of framing is a complex one, especially as the original intentions of the artist or of the patron are rarely known. In general, the aim of a museum in framing is to enhance the aesthetic qualities of a painting while also suggesting its historical and regional context.

The study of the picture frame has been revived in the last thirty years. Identifying where and when a particular frame was made can be difficult, because frames have almost always been altered and re-gilded. The attribution of frames depends on an accumulation of mostly secondary evidence, and individual framemakers remain largely anonymous, although some celebrated names emerged in the eighteenth century. Few documents exist that specifically link paintings and frames together. When frames appear to be original to the paintings they contain, it is possible to date them. From this stylistic analysis and comparisons of the moulding profiles will reveal a network of cross-references. Tracing the precise dates for the appearance of a new style of ornament is more elusive since the evidence is often very sparse. Useful points of reference are provided by the integral frames on

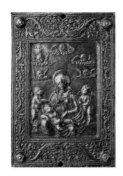

sculptural reliefs or decorative metalwork, and the appearance of mouldings in prints. (fig.3). However, some caution is needed when referring to frames represented in paintings or prints as one can only be sure that the artist depicted a frame design, not that it existed in reality.

Despite all of these complexities, looking at picture frames can be a rewarding process. Analysing the design of a frame brings into the foreground questions such as the origin of particular ornamental motifs, or the different techniques involved in carving and gilding; it also highlights the tradition of craftsmanship and virtuosity behind frame-making. When a painting still has its original frame, we can appreciate the visual relationship between the two that the artist would have intended. The later re-framing of pictures reminds us of the history of paintings as material objects that changed hands over the years. This book aims to provide specialist information about frame history and design, combined with an appreciation of the subtle relationships between pictures and their frames, and a sense of the importance of the picture frame in the history of art as a whole.

A glossary of specialist terms is provided on p.80, together with a short bibliography of literature in English. Terms found in the glossary are indicated in italics in the text. It has been necessary from time to time to make comparisons with frames outside of the Ashmolean's collection, and as far as possible these have been made with frames in the National Gallery, London. Scaled cross-section drawings of mouldings have been provided.

Fig.3: Anonymous Paduan School
Virgin and Child with two Angels
Plaquette
Bronze WA1888.CDEF.B656

11

1 Florence, early fourteenth century

Studio of Giotto di Bondone (? 1266/7–1337)
Virgin and Child
A332; WA1913.1
Presented by Mrs James Reddie Anderson, 1913

Poplar, water-gilt, punching, reverse: feigned
red marbling
Sight size: 28 × 19.5 cm; moulding size: 2.5 × 2.4
cm; picture size: 28.5 × 19.7 cm

This small panel is typical of private devotional paintings in early fourteenth-century Florence. Its frame is *engaged*, meaning that it is integral to the object. The moulding was nailed on the wooden panel and then both panel and frame were *gessoed* and gilded, punched and painted. The marbling on the reverse suggests that the panel could be viewed from both sides: it was probably made as a travelling altar to be hung by an iron ring. The sloping strips of the moulding allow the eye to move gently in repeating steps from one layer to the next in the painting. This type of frame may have been derived from that on the *Ruccellai Madonna* by Duccio of 1285 (Uffizi, Florence), which is in the same style with roundels.

Early Italian frames probably developed from a single plank of wood which was scooped out in the middle with chisels to provide a sunken surface on which to paint. The recessed surface would be protected by the remaining raised edges. Where portable altars consisted of two or more panels which could be folded shut for travel, the edges prevented abrasion and damage. These raised lips to some extent may have influenced the appearance of paintings. As figure compositions became more complicated with different layers of spatial depth suggested, the raised edges of the frame in turn were divided into steps which enhanced the sense of depth in the picture.

One of the earliest surving original frames of this type may be seen on *The Virgin and Child Enthroned, with scenes of the Nativity and Lives of the Saints* by Margarito of Arezzo, dating from the 1260s, now in the National Gallery (NG 564)

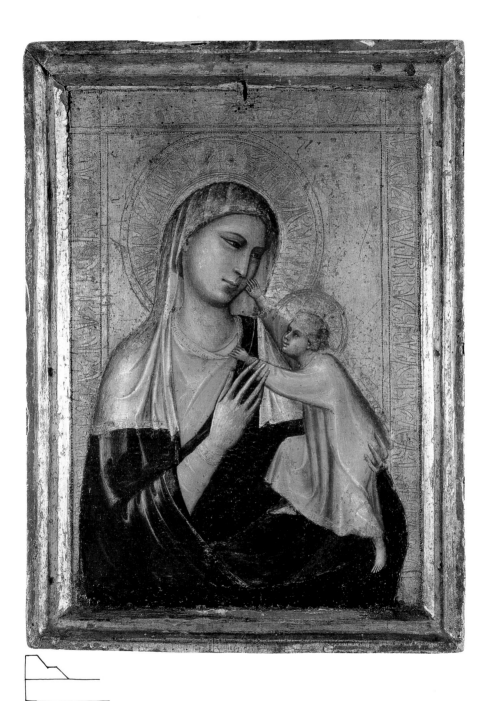

Scale 1:2

13

2 Siena c.1350–75

Attributed to Barna da Siena (active early four-
teenth century)
The Crucifixion and Lamentation
A73; WA1850.9
Presented by the Hon. William Thomas Horner
Fox-Strangways, 1850

Poplar, water-gilt, punching, reverse: green
painted moulding with porphyry field
Sight size: 47.5 × 32.7 cm; moulding size: 2.4 ×
2.5 cm; picture size: 47.3 × 32.9 cm

The *panel* is one of a pair of panels (a diptych) hinged together so as to open and close like a book, which formed a travelling altar. The left side of the diptych, *The Annunciation with Six Saints in Half-Length* is in the Gemäldegalerie, Berlin (inv.1142). The engaged frame has a well-balanced upturned *ogee* moulding which dips in and rises up, exploring the delicate space suggested in the painting. Similar mouldings may be seen on a small panel by a follower of Simone Martini *The Virgin and Child, sitting on a Pillow* also in the Gemäldegalerie, Berlin (inv.1072). There are slight differences but they are close enough to have been made in the same workshop.

The extensive use of gilding had a celebratory and devotional purpose. Gold, a very precious material, was deemed appropriate for religious art which would reflect the glory of God. Meanwhile the gilded background and frame suggest the existence of a sacred space separate from everyday life. The sense of pictorial depth in the picture is enhanced by the relationship between the mouldings of the frame and the punched decoration of the gilded border, which reads as an inner frame. An illusion is created whereby the painted figures are placed in front of the decorative border, and continue in an imaginary space behind the mouldings of the frame. The effect of relief provided by these subtle, shallow mouldings would have been stronger in flickering candlelight, since electric lighting produces a more generalised, flattering effect.

14

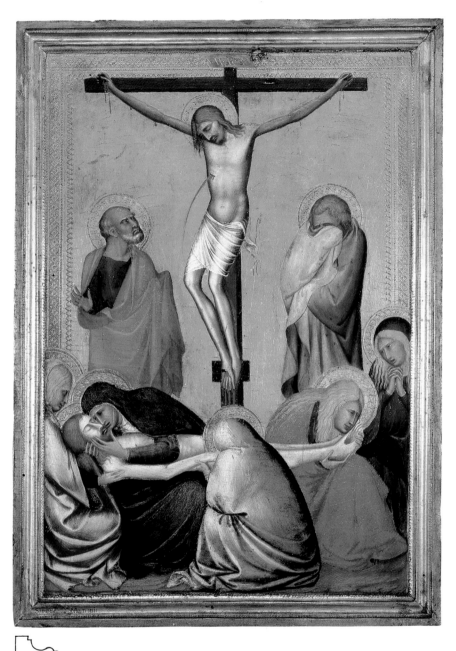

Scale 1:2

15

3 Siena, late fourteenth century

Andrea Vanni (c.1330 – 1413)
The Virgin and Child with the Angel of the
Annunciation in a roundel above
A696; WA1942.48
Presented by the National Art Collections Fund,
1942

Poplar, water-gilt, punching, reverse: red and
green marbling
Sight size:51 × 22 cm; moulding size: 2.2 × 2 cm;
picture size: 58.3 × 25.8 cm

This *panel* is the left hand half of a hinged diptych, or pair of panels, of which the other half is a *Crucifixion* (inv.1965.563) in the Fogg Museum and Art Gallery, Cambridge, Massachusetts. Its original engaged frames were attached to the panels before *gessoing* and gilding. This method of painting the image after making the frame maintained a clear visual relationship between the form of the frame and the illusion of form in the painting.

The top of the frame is triangular, ornamented with summarised acanthus leaves and *pastiglia* work, which visually draws the image upwards. This ornament is derived from the complex decoration found on larger altarpieces. *Pastiglia* is raised decoration made by dipping the brush in thick *gesso* and trailing patters on the prepared surface of the panel. Large altarpieces with their carved and gilded gables, tracery and finials in stone or wood essentially reflect the architectural forms and ornamentation of Gothic churches. Thus the altarpiece evoked the richness and glory of the House of God. Domestic altars and shrines such as this one in turn are small-scale versions of the forms of great altarpieces. Here, the backs of the panels are decorated with red and green marbling which may have had some symbolic significance (red and green are two of the liturgical colours) while also denoting the precious nature of the object, suggesting that it is worthy of the finest materials. Once closed, these panels would have been packed into a travelling case probably made of velvet and leather. The diptych with companion portraits of René d'Anjou and Jeanne Laval by Nicolas Froment of c.1474, in the Musée du Louvre, Paris, survives with its original red velvet-covered case.

Scale 1:2

17

4 Venice c.1500–1520

Traditionally attributed to Michelangelo
Buonarroti (1475–1564)
The Return of the Holy Family from Egypt (?)
A66c; WA1846.309
Presented by subscription, 1846

Poplar, carved and gilt, punched background
Sight size: 61.5 × 49.5 cm; moulding size: 7.7 ×
17 cm; picture size: 65 × 53.5 cm

Although this carved and gilt *cassetta* frame was origi-
nally made for an oil painting in or around Venice, it was
probably chosen for this unusual drawing on panel on
the basis of its visual strength. The word *cassetta*, mean-
ing little box, describes the simplified shape, while also
suggesting that such frames were like decorated caskets
housing important and valued objects. Gilt *cassette* with
shallow carved *frieze* ornament were widely made in
Italy from early sixteenth century to the middle of the
seventeenth century. This pattern was derived from the
entablatures of tabernacle frames made from the 1480s,
such as that seen on Giovanni Bellini's *Madonna and
Child with Saints* in the church of the Frari, Venice. An
altarpiece in the National Gallery, *The Madonna della
Rondine* by Carlo Crivelli (NG 724), still in its original
frame of *c.*1490–92, illustrates how an entablature of this
period could have influenced subsequent styles of *cas-
setta*.

 Cassette relate well to paintings with frieze-like
compositions that lead the eye through the subject at a
particular spatial depth. Here, in addition to the orna-
mental frieze there is a smaller panel sloping down to
the *sight edge*, which has punched decoration. The
frieze on this inner panel is fine and delicate, leading the
eye from the bold structure of the outer frieze into the
picture space. This sophisticated gradation increases
the visual impact of the painting, recognising the bold-
ness of the drawing and the fine details within a certain
pictorial depth. An example of this style of ornament
may be seen in the detail of a sculpted frieze in the lower
left hand corner of *Christ Amongst the Doctors* by
Jacopo Bassano (*c.*1510–1592) in the Ashmolean Mus-
eum (A771).

18

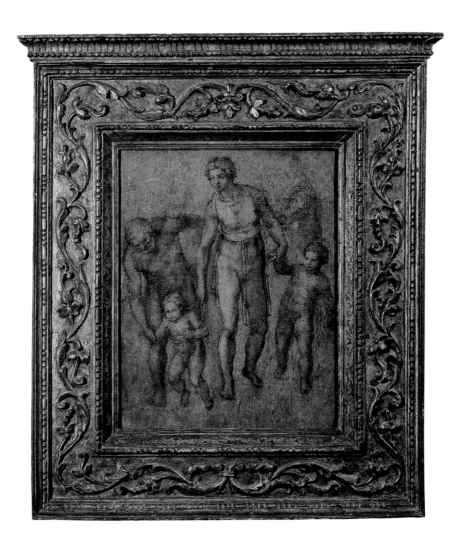

Scale 1:3

19

Bartolommeo degli Erri (active by 1430–after 1479)
St Vincent Ferrer Preaching
A93; WA1850.18
Presented by the Hon. William Thomas Horner Fox-Strangways, 1850

Poplar, carved pine and gilt, *cartapesta*
Sight size: 61 × 61.5 cm; moulding size: 2.2 × 11.7 cm; picture size: 62.2 × 61.7 cm

While the painting and the frame are both from the north of Italy, the frame dates from about eighty years later than the painting. According to the museum's *Annual Report* of 1953, the 'commonplace Victorian moulding' around the picture was substituted by an original frame of fine quality, adapted with a minimum of alteration. A label on the back of the picture indicates that the period frame was supplied by H.J.Spiller, a London frame dealer and frame-maker.

Shallow tabernacle frames of this design, using a *cartapesta* frieze-ornamented *cassetta* surrounded by an *entablature*, columns and base, are typical of Verona. *Cartapesta* is a type of ornament made of a pliable compound that is pressed out of moulds: it is made in lengths and then cut to size. Unusually the columns in this frame are adorned with winged heads of a lion and a cherub, reminiscent of details in the architectural decoration of the Palazzo Te, Mantua, by Guilio Romano (?1499–1546). Traces of blue paint in the columns suggest that there might have been incised (*sgraffito)* decoration in this area, which has been lost through abrasion and later re-gilding.

The visual relationship between the painting and the frame is well balanced. The tall narrow columns acknowledge the pinched space of the street scene while the simplified *cartapesta* ornament suits the provincial buildings in weight. However, an absolutely contemporary frame would probably have been made of a single moulding which would have been quite simple and shallow with a *sgraffito* decoration. A fine example of a precursor of the present frame is that on *The Mystic Marriage of Saint Catherine* by Andrea Previtali of c.1510, in the church of S. Giobbe, Venice.

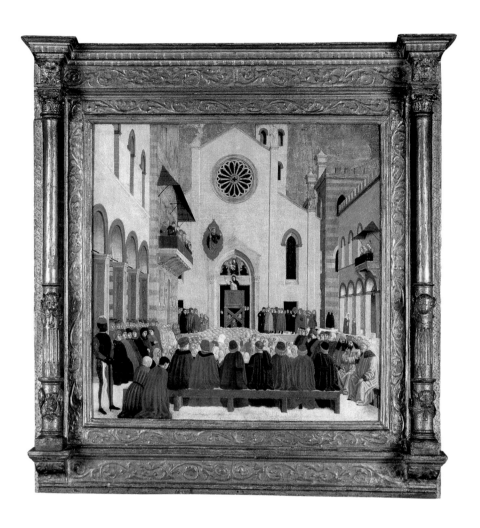

Scale 1:2

21

6 Venice c.1560–1580

Bernardino Licinio (c.1489–1549)
Portrait of a Young Man with a Skull
A721; WA1946.199
Bequeathed by Gaspard O.Farrer, through the
National Art Collections Fund, 1946

Poplar, carved walnut and parcel gilt
Sight size: 69 × 60.5 cm; moulding size: 6.2 × 14
cm; picture size: 75.7 × 63.3 cm

This frame is carved in walnut and it is *parcel gilt* in a technique known as *luminolegno*. This involves water-gilding only the highlights or accents of the frame. The play of light and shade is very marked, relating the frame well to the style of many Mannerist compositions of middle and late sixteenth-century Italian painting. This distinctive sense of tonality in the frame ultimately derives from fifteenth-century sacristy furniture and from sixteenth-century *cassone,* or luxurious domestic carved chests. The frame was reduced by Cyril Mander in 1956 at the centres and corners to cover canvas additions to the painting.

Luminolegno frames in the middle of the sixteenth century often included a convex *frieze* as this example illustrates, with the frieze here embellished by a vine tendril. The bold moulding at the *sight edge* (where the frame meets the picture) suggests that the frame was originally made for more forceful composition. However the convex frieze runs into a series of hollow, *astragal* and *ogee* mouldings, avoiding any interruption between frieze and *cornice.* This continuum of mouldings suits the composition, providing an understated rhythm and a sonorous, dark surround which accentuates the brooding atmosphere of the portrait.

A fine example of a frame in the same style, through entirely gilt, is on a portrait of Doge Alvise Mocenigo of 1570–1577 by Tintoretto, in the Gallerie dell'Accademia, Venice (inv.233).

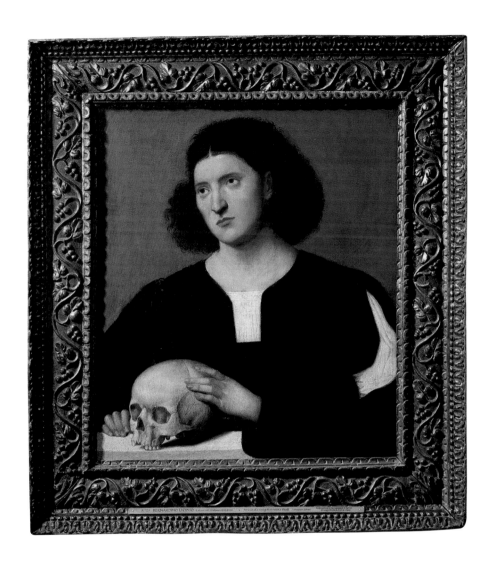

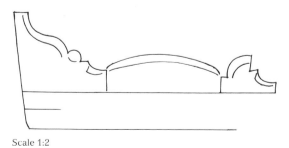

Scale 1:2

23

7 Florence c.1570

Agnolo Bronzino (1503–1573)
*Don Giovanni de'Medici c.*1555
A105; WA1850.32
Presented by the Hon. William Thomas Horner
Fox-Strangways, 1850

Poplar, carved and gilt, grisailles
Sight size: 64.5 × 51 cm; moulding size: 9.8 ×
21.7 cm; picture size: 66.2 × 52.8 cm

This fine frame may have been originally made for a *Cleopatra* which was presented to Christ Church by the Hon. W.T.H.Fox-Strangways in 1834. An old label on the back of that picture suggests that both the painting and its frame were by Francesco Salviati (1510–1563). The picture is now attributed to an anonymous Florentine artist of the mid-sixteenth century. Before Fox-Strangways gave *Cleopatra* to his old college, its frame had been removed. He had acquired the Bronzino in 1830, and he presented it, probably framed as it is today, to the University in 1850. However, the first documentary evidence for the portrait being in its present frame dates only from 1891. By 1910 the frame had been removed again, to be replaced in 1951. The original *sight edge* moulding was probably removed when the portrait was first fitted in the nineteenth century.

The monochrome decorative panels, fitted separately into the frieze, may derive from designs by Giorgio Vasari (1511–74). With their allegorical figures and playful putti they are typical of Mannerist taste for the elaborate and the erudite. Such monochrome scenes are found in subsidiary areas of fresco decoration, usually with festive stucco surrounds, and in inlaid panels in furniture of the type seen in the *Portrait of a Young Collector* by Alessandro Allori (1535–1607) of 1561 in the Ashmolean (A1123). In 1951 the lower left panel was completely re-painted by the restorer S.Isepp; the top two panels were subsequently restored by J.C.Deliss. The *cassetta* format has a strength and formality which suits the painting. The wide moulding is typical, and with its shaped panels gives a more sculptural quality to the carved and gilt ornament. The grotesques at the corners are powerful elements which appear to enlarge Bronzino's portrait of the young aristocrat. These designs recall the learned and luxurious atmosphere of the Medici court. Originally they would have evoked the antique as well as adding a sense of foreboding to the *Cleopatra*. Close comparison can also be made with the arrangement of mouldings on the Porta delle Suppliche at the Uffizi, Florence, designed by Bernardo Buontalenti (1531–1608) in 1576–7. The grotesques in the lower panels are particularly like those of the Ashmolean frame.

24

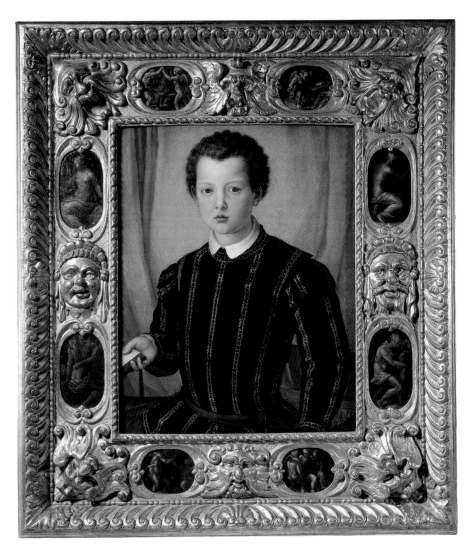

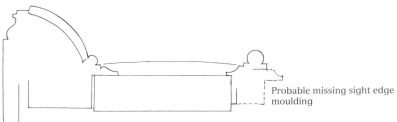

Probable missing sight edge
moulding

Scale 1:3

Anonymous Italo-Flemish artist, c.1560s
The Adoration of the Shepherds
A512; WA1937.122
Presented by the National Art Collections Fund,
1937

Poplar, carved and gilt, punched, smalt
Sight size: 113 × 110.8 cm; moulding size: 7+ ×
21.2+ cm; picture size: 119 × 111.3 cm

This fine *aedicular* frame was probably set above an altar table and still retains its original inscription even though it has been adjusted in size several times. Classical architecture provides the source for the form and decoration, where a pair of composite columns with bases support an *entablature* or horizontal beam with a decorative *frieze*. Altarpieces were designed with classical architectural motifs so as to reflect contemporary church architecture, while also adding to the sense of dignity and authority carried by the sacred scenes they enshrined. The inscription on an oval cartouche at the base tells us that Sister Rafaella Ghelfonia and Sister Gabriella Tomodellia had this made in the year of Our Lord 1578. The frame was acquired in London in 1955 already reduced in height and width. The missing capitals and fluted *slip* were added, and the restorer J.C. Deliss extended the painting along the lower edge in order to fit the frame. During conservation in 2000 this painted addition was removed and a *slip* added to the lower *sight edge* of the frame.

Stylistically the ornamental elements are a mixture of old and new. The hanging clusters of leaves and fruit are first found around 1520–1530, whilst the grotesque mask at the top and the scrolls around the inscribed cartouche are dateable to between 1570 and 1580. Such motifs are found in *Sansovino* frames, popular in this period, which incorporate decorative elements of volutes, interlaced scrolls, masks and other complex ornament. Their sources are found in Tuscan and Emilian stucco-work of the early and mid-sixteenth century and in Venetian carved or stucco ceiling decoration by the sculptor Alessandro Vittoria (1525–1608) and his associates. The extensive use of blue paint in combination with the gold recalls traditional customs in church decoration, as in blue ceilings decorated with gold stars.

The frame still suggests the visual weight of sixteenth-century altarpieces in relation to their paintings. The deep *cornice* moulding recalls its derivation from a canopy as seen in antique aediculae. In the National Gallery the frame on *The Virgin and Child with Mary Magdalen and Saint John the Baptist* by Andrea Mantegna (NG 274), probably made in the Veneto in the middle of the sixteenth century, has a similar scheme of entablature, columns and base.

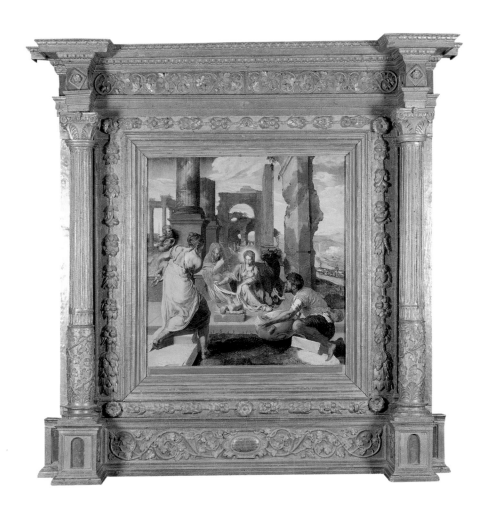

Scale 1:3

9 Tuscany c.1580–1590

Ermanno Stroiffi (1616–93)
The Madonna and Child in Glory with Saints John the Baptist, James and Francis
A1002; WA1963.63
Purchased through the V&A Purchase Grant Fund, 1963

Poplar, black mordant gilt mouldings, water-gilt, *sgrafitto*
Sight size: 106 × 65.5 cm; moulding size: 6 × 16 cm; picture size: 106 × 67.5 cm

This painting is a small-scale oil-sketch for an altarpiece in the Chiesa dell' Ospedaletto, Venice, probably of 1652. Still in its original location, the large, finished picture is framed with marble pilasters and spandrels in a different design from that envisaged in the oil-sketch. This black and gold late sixteenth-century Tuscan reverse *cassetta* frame was purchased for the oil-sketch in 1963; it has been reduced by an additional *sight edge* moulding. The centre and corner decoration consists of a wide and very fine *cauliculi* and fleur-de-lys *sgrafitto* pattern (a cauliculus is the element of a volute which is overlaid by an acanthus leaf). Once the *frieze* was gilded, black paint was added over the entire frame, and then scraped back with a stylus (hence *sgraffito*, meaning scratched) to make this decorative pattern; water-gilding was then applied to the mouldings.

This frame has been applied in the tradition of black and gold gallery framing (although it is interesting that an earlier frame should have been chosen for the painting by the museum's curators in 1963). It provides sufficient visual strength to an oil-sketch which might otherwise appear weak when hung beside more finished paintings. The fact that the frame pushes the picture forward from the wall accentuates its visual impact in the gallery, while also adding further pictorial space. The frame's dark tonality and gilt decoration are also appropriate for the rich chiaroscuro of the painting. Black and gold frames appeared throughout Europe before ebony was imported and were probably inspired by black or very dark marble altarpiece frames with applied gilt bronze ornament which may have first appeared in Flanders around 1480. An example of a black and gold early Flemish frame may be seen on a triptych in the National Gallery of *The Virgin and Child* of c.1500 by a follower of Hugo van der Goes (NG 3066).

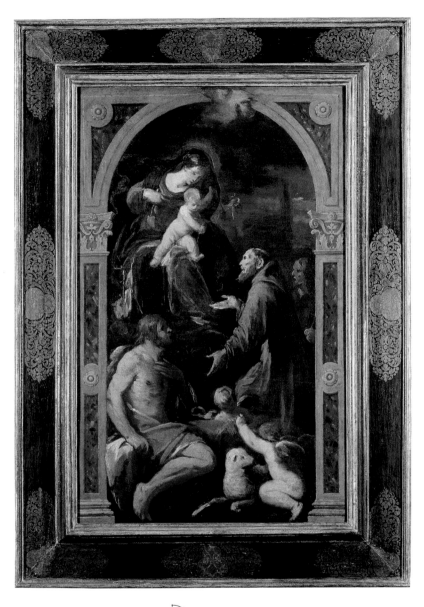

Scale 1:3

10 Venice c.1600

Attributed to Rodrigo de Osona (active in
Valencia 1463–1513)
The Dead Christ Supported by an Angel
A921; WA1958.10
Purchased with help from the National Art Collections Fund, 1958

Inner frame: pine, gold
Outer frame: pine, walnut, black, *shell gold,*
marble
Sight size: 21.5 × 15.5 cm; moulding size: 3.2 ×
8 cm; picture size: 21 × 15 cm

The *engaged ogee* moulding around the painting is the original and probably the complete frame on this Spanish *panel* of about 1510. The outer frame was purchased in 1959: the museum's *Annual Report* noted that it was chosen as an appropriate frame for the subject and colour of the painting. It was reconstructed by Cyril Mander to fit around the panel. Made in Venice in about 1600, this is a type of *tabernacle* frame made of pine and faced with sawn walnut mouldings. The black finish is ornamented with very fine *shell gold* decoration, and punctuated with a symmetrical arrangement of coloured marble insets. More elaborate examples of this particular style exist in the form of caskets with panels and columns, incorporating decorative elements of rock crystal and silver gilt mounts. Such elaborate objects were made as shrines to house especially sacred relics: a fine example survives in the basilica of Santa Barbara, Mantua.

This stylistic context suggests that the tabernacle frame was originally made for a devotional object. While this outer frame may have been added to increase the size of the original frame, so that the small panel would not be visually lost on the gallery wall when hung beside larger paintings, it also has the effect of reframing the panel in the way that venerated relics were enshrined in order to enhance their significance and endow them with greater prestige. Moreover, the darker surround of this tabernacle frame increases the luminosity of the gold ground panel, and the fine shell gold provides a counterpoint to the punched decoration. The panel itself would probably have been part of the *predella* or lower section of a large, complex altarpiece, thus intended to be viewed in a rich and colourful setting.

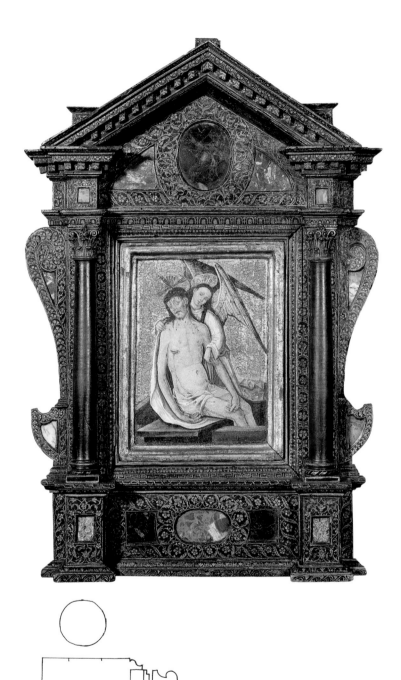

Scale 1:2

31

11 Southern Spain *c.*1660

Federico Barocci (1535–1612)
Saint Dominic de Guzmán receiving the Rosary
A709; WA1944.100
Purchased, 1944

Carved, ripple and gilt, blue
Sight size: 54 × 38 cm; moulding size: 3.9 × 9.3
cm; picture size: 54 × 38 cm

This small-scale oil-sketch, essentially a study of light and shade, was part of Barocci's preparation for an altarpiece destined for the church of S. Rocco, Senigallia, painted between 1588 and 1591. The oil-sketch has a reverse *ogee* frame with carved acanthus leaves; on either side of these are two ripple mouldings, and the frame is finished in blue and gold. Whilst the pattern may seem unusual, ripple moulding (the first mechanically manufactured ornament) was common in Europe during the first half of the seventeenth century. Perhaps ultimately deriving from Islamic ornament, its flowing forms were extremely elegant. Ripple mouldings were often used in Spanish, Italian and Central European frames, imparting a new visual rhythm to familiar forms.

Whilst the Ashmolean frame is bolder and later in date than Barocci's oil-sketch, it foresees the grandeur of the altarpiece that is suggested in the sketch. Moreover, the fact that the frame sweeps away from the picture towards the wall effectively pushes the monochrome sketch forward. The ripple mouldings on the sight and back edges which touch on the summary brushwork strengthen its visual impact and accentuate the powerful sense of volume and energy within the painted composition. Other examples of this more complex style which combines carving flanked by ripple mouldings may be seen in the backgrounds of two paintings by Juan de Valdés Leal of 1660, the *Allegory of Vanity* (Wadsworth Atheneum, Hartford) and the *Allegory of Salvation* (York City Art Gallery). Here the carving on the frames appears to depict the instruments of the Passion.

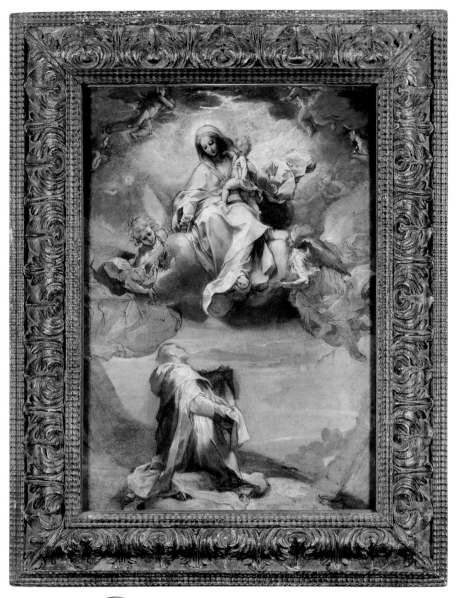

Scale 1:2

12 Holland c.1670

Elias van den Broeck (1650–1708)
A Vase of Flowers
A540; WA1940.2.16
Bequeathed by Daisy Linda Ward, 1939

Limewood carved and gilt on hide glue
Sight size: 90 × 70 cm; picture size: 90 × 71 cm

The word *auricular*, meaning 'of the ear' is used to describe a type of mid seventeenth-century frame, which employs fleshy, organic ornament such as melting masks, animals skins, and marine elements. Auricular frames developed from an earlier tradition of applying ornament in the form of grotesques, inspired by ancient Roman decoration. These first appear on central Italian picture frames around 1505. Fantastic masks, sea-monsters and bizarre variations on natural forms are found in designs for goldsmiths' work from the 1520s onwards, while marine elements – tritons, dolphins, seaweed, and scaly fish – were increasingly popular in sculpture and fountain design. The work of two influential craftsmen in Holland, Adam van Vianen (1569–1627) and Johannes Lutma the Elder (1584–1669), was especially important in establishing the auricular style. They designed *repoussé* silver with refined ornament called *kwabwerk*: these zoomorphic or fleshy forms may have been stimulated by contemporary anatomical studies. Volumes of prints based on their designs, characterised as 'artful inventions' or 'drolleries' for silversmiths, sculptors and painters, were published in Amsterdam in the early 1650s, and this style of ornament appeared in picture frames about 1655. Not long afterwards, these auricular frames included festoons to contrast with the relatively abstract *kwabwerk*.

The auricular frame on a *Vase of Flowers* can be dated to c.1670. It is carved in limewood and the gilding is applied on a base of hide glue. This technique enables the wood grain to be filled without using *gesso*, which would disguise the clarity of the carving. The centre motif at the top edge is a rolled-up mask, with fleshy folds below, while dolphins are found at the upper corners, with a sequence of leaves and fruit emerging from their mouths. This succession acknowledges the cascade of flower heads within the painting. A wonderful sense of energy is conveyed by the rhythmic movement of the carving and by the individual motifs. Ripe fruits are shown splitting and bursting open, or are hollowed out, having already been eaten. An example of an auricular frame with *kwabwerk* may be seen in the background of *A Man and a Woman seated at a Virginal* of c.1665 by Gabriel Metsu in the National Gallery (NG 839).

34

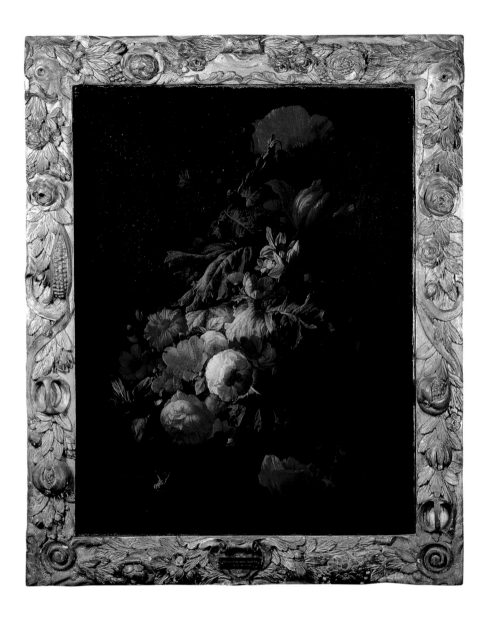

13 England, *Grinling Gibbons c.*1681–1682

John Riley (1646–1691)
Elias Ashmole c.1680–1683
F730
Presented by Elias Ashmole, 1683

Limewood carved and gilt
Sight size: 124 × 101 cm; picture size: 124 × 101 cm

This frame was carved in limewood by Grinling Gibbons (1648–1721) in 1681 – 1682, providing an important point of reference for Gibbons' early career. He worked extensively at this time at Petworth House, Sussex, with the assistance of John Seldon. The frame was described in the first Ashmolean catalogue of 1685 as carved in limewood and a later reference indicates that it was gilded in 1729–1730. The arrangement of the ornament is derived from the carved decoration of contemporary wall panelling. There is no moulding to follow the form of the picture which would have introduced the frame gradually to the painting. The sides are composed of two hangings of tied drapery with overlaid festoons of fruit, wheat and flowers which are cut square on the *sight edge.* The top is principally a cartouche containing Ashmole's coat of arms and motto ('ex uno omnia') surmounted by the figure of Mercury, who symbolizes the constant activity of the human intellect. The cartouche is supported by the cosmological twins, Castor and Pollux. There are thin, pierced scroll-like tendrils on either side and a festoon along the lower side. The centre ornament and lower festoons project strongly, taking on a life of their own as sculptural elements. The frame is intended to have a strong impact, attracting the viewer's attention to the painting rather than relating proportionally to the spatial depth and to the form of the sitter. It provides an independent, dramatic accompaniment to a majestic portrait, while the elegant fall of drapery within the painting is recalled in the detail of the frame.

This frame is unlike the related frames on the portraits of Charles II and James II, also from the Museum's foundation collection, which were originally gilded. The display of ungilt carving was probably due to the appeal of Gibbons' virtuosity, since gilding would have reduced the crispness of the carving and diminished the frame's sculptural impact. However, with time, the pale, freshly carved limewood would have discoloured with exposure to light and atmosphere, so it was subsequently gilded. For the two royal portraits, gilding would have been more appropriate from the outset.

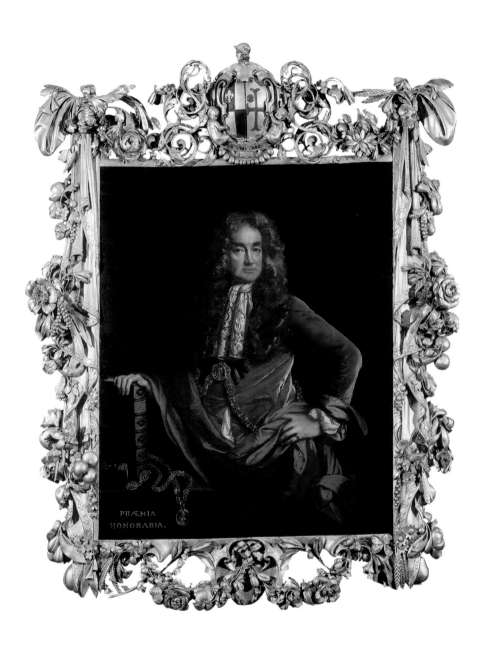

14 Holland c.1690

Jacques de Claeuw (c.1618 – after 1676)
Still life with a Violin
A544; WA1940.2.20
Bequeathed by Daisy Linda Ward, 1939

Pine, palisander
Sight size: 31.5 × 45.5 cm; moulding size: 5.6 × 9 cm; picture size: 32 × 46 cm

This polished frame is contemporary to the painting and is in a style used for decorative easel paintings. It is made of polished palisander veneer and mouldings. Palisander has characteristically large dark patches, a quality which framing could exploit. The scale and tonality of this frame is well suited to the meditative theme and austere palette of the painting even though the frame is not original and has been reduced in size to fit the painting.

Polished veneer frames evolved from painted oak *cassette* at the beginning of the seventeenth century when ebony was discovered by United East India Company traders and imported initially to Holland as ships' ballast. An expensive and exotic wood, ebony was suited to gleaming, fine mouldings or to gently undulating surfaces. The fine structure of this hardwood led craftsmen to develop new skills. The frame profiles changed from angular *cassette* to shallower mouldings because the rarity of the wood required sparing use and therefore different woodworking methods were developed. In the background of another Ashmolean painting, *A Lady Seated at a Table* (A124) attributed to Simon Kick (1603–52), three black framings can be seen, on a portrait, a mirror and a landscape, testifying to the popularity in Dutch interiors of dark, polished frames. Ebony was not always jet black: lighter-grained varieties such as coromandel were also used. The taste for expensive and rare woods such as ebony and macassar also encouraged the development of substitute materials like ebonised pearwood or other fruitwoods, which could be stained black to emulate the effects of ebony.

A larger version of this frame can be seen on *A Cock and Turkey Fighting c.*1690 by Melchior d'Hondecoeter (1636–1695) at Dyrham Park, Gloucestershire (National Trust). This frame gives every indication of being original to the painting.

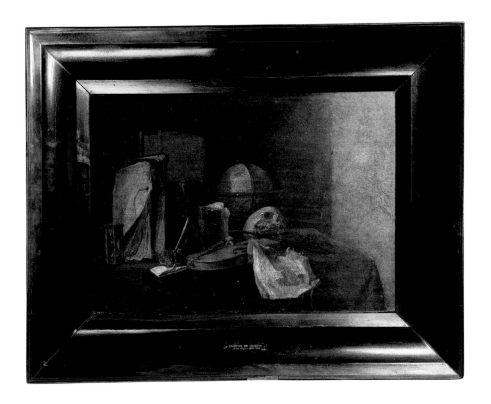

Scale 1:2

15 France c.1670–1680

Domenichino (1581 – 1641)
Vision of Saint Jerome
L.99.12
On loan from Sir Denis Mahon C.B.E., F.B.A.

Lime, carved and gilt
Sight size: 49.5 × 38.5 cm; moulding size: 6.4 ×
11.4 cm; picture size: 49.4 × 37.2 cm

This densely ornamented French frame was probably made to re-frame the *Vision of Saint Jerome*, which had been sent from Rome to Paris before 1672. The design is particularly compact and complicated and has a visual relationship to this painting which strongly suggests that it was made for it. The sophistication and restraint of the ornament echoes the elegant expressiveness and modulated classicism of the composition. The moulding profile is typical for this date with a small *ogee sight edge*, hollow and large *ovolo* facing inwards and a lower *back edge*. However, this moulding has a proportionally smaller front hollow and the carving on the ovolo is contained by a tight blank *astragal*. This is separated by only a small hollow above the carved upper edge of the complex back edge ornament. The unusually narrow sight-edge ornament focuses the viewer's attention on the fine brushwork and the subtlety of expression in the painting.

The intense carving and very controlled gradations of depth in this frame suggest it was made for a painting on copper, as such paintings were traditionally given highly refined frames. Although many paintings on copper survive, very few retain their original frames. Some fine frames which show original nail holes tight into the corners of their *rebates* may have held sheets of copper rather than wooden panels. A good example of an originally framed painting on copper is the *Christ in the Garden of Gethsemane* and *The Sacrifice of Isaac*, a portable altar of 1608 by Jacopo Ligozzi (1547–1627), now in the Allen Memorial Art Museum, Oberlin, Ohio. It has a macassar and rose wood frame set with semiprecious stones.

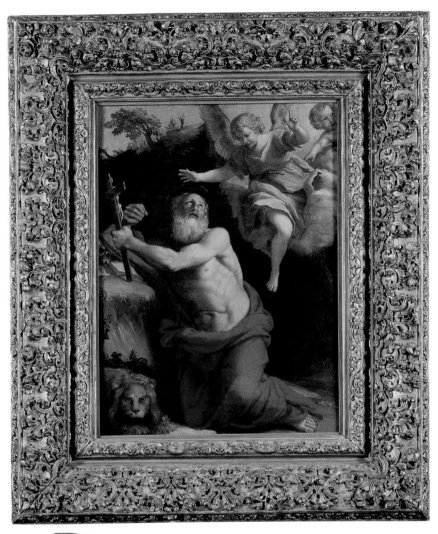

Scale 1:2

16 Paris c.1715

Circle of Paolo Caliari, called Veronese
(1528–88)
*The Flight of Achior from the Camp of
Holofernes*
A377; WA1926.2
Presented by Mrs Florence Weldon, 1926

Oak backframe and feather keys, limewood
upper mouldings. Carved and gilt
Sight size: 26.2 × 56.8 cm; moulding size: 5 × 12.7
cm; picture size: 27 × 57 cm

One of six scenes from the apocryphal *Book of Judith*
which were painted in the 1550s by an artist close to
Veronese, this picture and its companions (also in the
Ashmolean) were framed as a set. The quality of the
framing is very high, although the frames were re-gild-
ed sometime in the second half of the nineteenth centu-
ry. They were then part of the Methuen collection at
Corsham Court.

The arrangement of the moulding profile is how-
ever reversed from that of a typical late Louis XIV or
early Régence moulding. Rather than falling in towards
the painting, the principle *ogee* moulding falls away
towards the wall. A similar sequence of mouldings is
sometimes seen in Louis XIII frames around 1630 which
were probably derived from Neapolitan designs. Bear-
ing in mind that the Ashmolean paintings are Venetian
and relatively small in size with forceful rhythms, a con-
ventionally inward-moving moulding would have been
constraining. Here the fine *sight edge* of reeds bound
with acanthus leaves picks up on the sketchy brush-
work, while the hollow describes the shadows behind
the figures. The high, sweeping reverse ogee moulding
ornamented with centre and corner cartouches, with
interlaced *cauliculi* on a finely cross-hatched back-
ground, lifts the whole composition forward in a man-
ner more Italian than French. The detailed surface
ornament is clearly part of the Louis XIV style. Never-
theless this encourages the viewer's eye to move across
the whole surface of the painting. Interestingly, the use
of a strong reverse moulding goes some way towards
suggesting a late sixteenth-century Venetian setting
which would probably have included imposing architec-
tural volutes.

Two possibly original framings of this period with
conventional ogee mouldings may be seen on *The Boar
Hunt* and *The Hunting Party* by Joseph Parrocel (1646–
1704) in the National Gallery (NG 6473 and 6474). Anoth-
er comparison can be made with the *Pietà* of 1637 by
Jusepe de Ribera (1591–1652) in the Certosa di San Mar-
tino, Naples. This retains its original frame, which has a
very similar profile arrangement to the Ashmolean
frames.

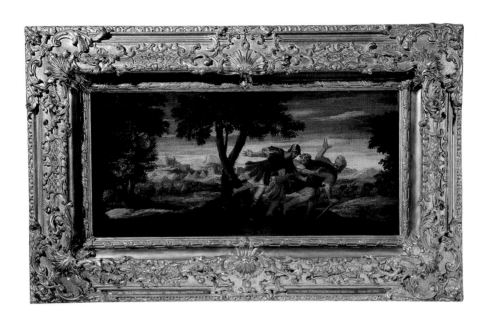

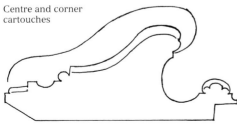

Centre and corner
cartouches

Scale 1:2

17 England *c*.1755

Giovanni Paolo Panini (1691–1765)
Roman Capriccio
A725; WA1946.265
Presented by the Rt. Hon. Earl of Donough-
more, 1946

Pine, carved and gilt
Sight size: 176.5 × 127 cm; moulding size: 6.4 ×
13.4 cm; picture
size: 176 × 126 cm

This English rococo picture frame was probably origi-
nally made for a full-length portrait of *c*.1755. The roco-
co style was popular in England from the 1730s, thanks
largely to the influence of French art and interior design,
and to the immigration of Huguenot craftsmen. It
reached its peak of popularity in the 1750s and 1760s.
'Rococo' was a term widely used in the nineteenth cen-
tury to describe a style of asymmetric ornament employ-
ing curves, festoons, shells and S or C-scrolls. In
eighteenth-century England, rococo picture frames
were described as in the French taste, or as swept
frames because of their sweeping curves. Here, the
design is based on a Louis XV pattern of *c*.1750 which
has been simplified and elongated. The acanthus leaf
and reverse husk *sight edge* ornament is bolder, the rib-
bon and reed *top edge* moulding is higher and not lean-
ing towards the sight edge, and the corner *paterae* are
larger and more heavily silhouetted. The visual relation-
ship between the frame and the painting is freer and
more atmospheric that its Louis XV prototype, which
would have conveyed a controlled refinement.

 In the eighteenth century when fanciful views of
antique Rome such as this were collected by British
travellers on the Grand Tour, they were often framed on
their arrival in England. This English frame was applied
to the picture in 1954 within that taste, though the mid
nineteenth-century regilding was removed leaving a
matt or *decapée* finish consistent with the framing of
French Impressionist pictures (see no.28). The mus-
eum's Annual Report of 1954 remarks on the removal of
the 'ugly Victorian gilding' of the frame, which was
probably purchased in London. The sight size was
enlarged near the corners to take this canvas. The centre
and corner ornament of the frame acknowledges the
massive quality of the ancient ruins, while the rhythm of
the swept mouldings echo the graceful movements and
gestures of the foreground figures. An example of eigh-
teenth-century Grand Tour framing may be seen in the
Cabinet at Felbrigg, Norfolk (National Trust).

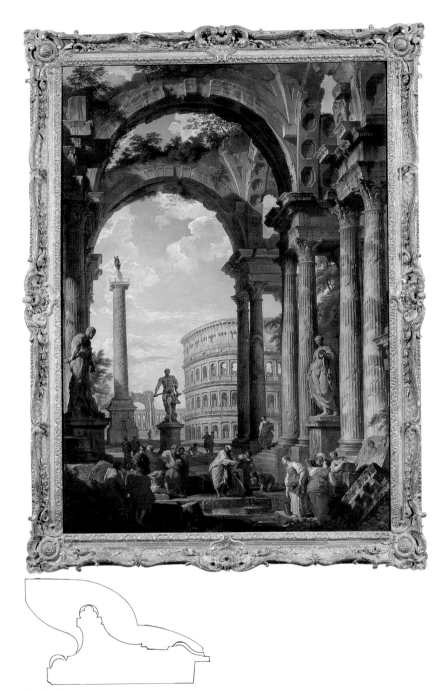

Scale 1:3

45

18 England *c*.1765

Paolo de Matteis (1662–1728)
The Choice of Hercules 1712
A1116; WA1980.92
Purchased through the National Art Collections
Fund, 1980

Pine, carved and gilt
Sight size: 196.5 × 255 cm; picture size: 198.2 ×
256.5 cm

The Choice of Hercules was commissioned by Anthony
Ashley-Cooper, third Earl of Shaftesbury, in Naples in
1712. Although its original frame is unrecorded it is like-
ly that the picture would have been framed with a plain
dark moulding, its austerity in keeping with the intend-
ed moral message of the picture that the path of Virtue
must be the choice of rational human beings. This fine
English rococo frame was made *c*.1765 for the painting
which hung at St Giles House, Dorset. The carving is in
the manner of Henry Flitcroft (1697–1769) who was
employed on the re-decoration of St Giles House in the
1740s. Upon the painting's acquisition in 1980 the frame
was re-gilded by Frank Samuels.

 Here the ornament is loosely symmetrical on the
vertical axis with a serrated *sight edge* and extending
decorative motifs. *Rocaille* (shell-derived background
ornament, with mollusc or pearl centres) and volutes
form the basis for a variety of ornament. At the top is a
pierced asymmetrical cartouche with a quiver, arrows
and tendrils, while bullrushes emerge from behind
volutes and corner panels. At the sides, the ornament
includes winged dragons and water cascading from
urns, elements found in chinoiserie decoration which
was popular in England at this time. The serrated sight
edge, and the extension of the ornament into the picture
space – particularly the playful motif of dripping water
above – is absolutely typical of rococo design, in which a
frame might respond to the decorative motifs and flow-
ing brushwork within a painting. Here, the sober, classi-
cal mode of the painting is undercut and even subverted
by the capricious, witty qualities of the frame.

 This frame follows a tradition of interior design
where mirror frames were applied to paintings. Since
they do not relate to the imagined space of a painting,
rococo mirror frames can incorporate exuberant flour-
ishes and restless movement. This type of framing
maintained symmetry in the decoration of a room or
emphasised the painting if it was central to the design,
for example set above a mantelpiece. A fine example of a
striking overmantel may be seen in the saloon at
Saltram, Devon (National Trust), designed by Robert
Adam (1728–92).

19 England *c.*1764

Pompeo Batoni (1708–1787)
Portrait of David Garrick 1764
A61; WA1845.61
Transferred from the Bodleian Library, 1845

Pine, carved and gilt
Sight size: 73.5 × 61 cm; moulding size: 5.9 × 9
cm; picture size: 76 × 63.5 cm

This appears to be the original frame for the portrait of David Garrick which was painted in Rome as a gift from the actor to the young Richard Kaye, its original owner. Made in England, the frame is very closely modelled on a Roman pattern of *c.*1740. The profile is made up of alternating convexities and concavities, where the convexities are divided into major and minor elements. The *sight edge* is a characteristic acanthus leaf and shield, the *top edge* a twisted ribbon and the *back edge* an acanthus leaf. This arrangement was designed to be articulated for a wide variety of styles and subjects of paintings, often with further refinement of ornament in the concave elements.

The style first appeared in Naples in c.1660 and came to England with the Grand Tour where it continued to be popular until about 1820. In Italy this type of frame is known as a Salvator Rosa and in England, a Carlo Maratta frame. Salvator Rosa (1615–73) worked extensively for the open market, framing his pictures carefully in order to increase their appeal to customers, and retaining the frame once a work had been sold: according to a contemporary source, he said that the frame functioned as 'un gran ruffiano' (a pimp) for the picture. The style would have been familiar to British Grand Tourists and artists viewing the great Roman collections, and appropriately Richard Kaye seems to have arranged for the portrait to be framed in this way (see no. 28 for an example of an earlier Salvator Rosa frame of *c.*1700). In mid eighteenth-century England such frames were referred to as Carlo Maratta frames, because of his association with re-framing schemes which used the Salvator Rosa style. While particularly popular for portraits, the Maratta style was chosen by Hogarth in or before 1751 for his *Marriage à la Mode* series (National Gallery, NG 113–118). It proved a graceful yet imposing alternative to the more fragile and exuberant rococo frames that were popular at the time.

A label on the stretcher reads 'James Wyatt carver and gilder. Print seller and Publisher. Picture frame and Looking glass manufacturer, 115 High Street, Oxford, paintings carefully cleaned, lined and repaired.' It was probably this well-known family firm that re-backed and regilded the frame in 1862.

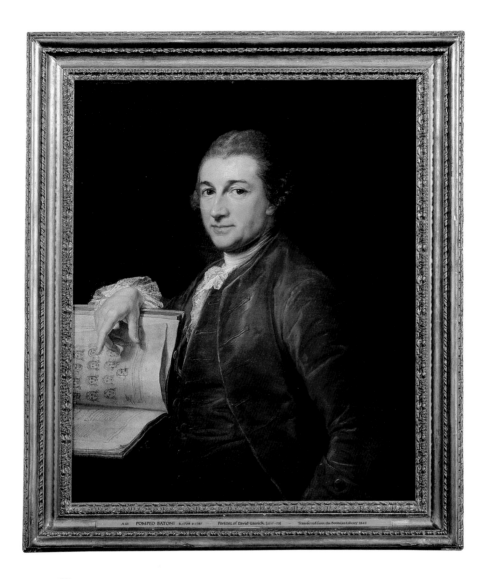

Scale 1:2

49

20 France c.1780

Etienne Aubry (1745–1781)
Portrait of a Gentleman c.1777
A1139; WA1986.76
Purchased to mark the Directorship of Sir David
Piper, 1986

Oak and lime, carved and gilt
Sight size: 62.5 × 51 cm; moulding size 2.7 × 8.6
cm; picture size: 65 × 54 cm

This oval Louis XVI frame has a well balanced design
with a *fronton*. Although contemporary with the paint-
ing, the frame was not applied until 1986. It replaced a
similar style oval frame that also had carved ornament
of pearls and leaves, which were in reverse order with-
out a cresting. This cresting or *fronton* is a cartouche
with extending laurel and bay leaves. It gives a positive
emphasis to the painting like a hat to a face, and the
whole ensemble, the shallow profile of the moulding,
with a flat top edge, endows this tranquil, good-
humoured portrait with an air of gravity. Meanwhile,
the gentle rhythm of the *sight edge* ornament acknowl-
edges the lively fall of the sitter's cravat.

Oval picture frames were reasonably common in
France c.1770–1790 and their use may have been stimu-
lated by the taste for antique Roman cameos. This par-
ticular shape of oval is characteristic of the Louis XVI
style which is more elliptical than the Baroque oval. A
fine example of a neo-classical oval frame may be seen
on *Shepherd and Shepherdesses Reposing* c.1761 by
François Boucher, in the Wallace Collection, London,
which is stamped on the reverse with the name of the
maker, H. Létonné.

Original size of rebate

Scale 1:2

21 England c.1860

Jean-Baptiste-Camille Corot (1796–1875)
Madame Bison 1852
A632; WA1940.1.14
Bequeathed by Frank Hindley Smith, 1939

Pine and gilt composition
Sight size: 32 × 25 cm; moulding size: 7 × 13 cm;
picture size: 32 × 25 cm

The French-revival frame in a style of *c.*1770 on this small dark portrait would have enlivened it beside other frame styles of the late nineteenth century. It was probably made in Manchester, according to an incomplete label on the reverse ([]Carver and gilder [] Picture frame Make[r] 7 Police Street, St. Ann's Street, Manchester).

The frame is based on a style that historians have called Transition, which appeared *c.*1755–1775, between Louis XV rococo patterns with swept rails and *rocaille* ornament and more formal Louis XVI neo-classical patterns. The characteristic form of the Transition style was of a neo-classical pearl and lotus leaf on the *sight edge* with swept rails on the top and back edges. The pierced elements are typical allowing the viewer to glimpse through the apertures the different swept forms of the back edge. With *composition* revivals, such as this frame, pierced ornament is more restricted due to the brittle nature of the material. Composition is a pliable material made of whiting, glue, oil and resin, and long runs of ornament were made from moulds.

The picture was originally glazed in front of the *slip*, since the condition of the latter is better than that of the outer frame. These slips are usually matt in tone, very plain and often bearing an inscription. The presence of the glass would have meant that the sight edge of the frame would be read as that above the glass, with the slip below functioning as a mount or border for the painting rather than as part of the frame. Without glass the frame appears to begin at the inner edge of the slip and now looks too wide and deep for the painting.

The frames on *Madame Bison* and the companion portrait of her husband (A631) maintain the complex description of space found in French mid eighteenth-century framings, but in a sharper revival form.

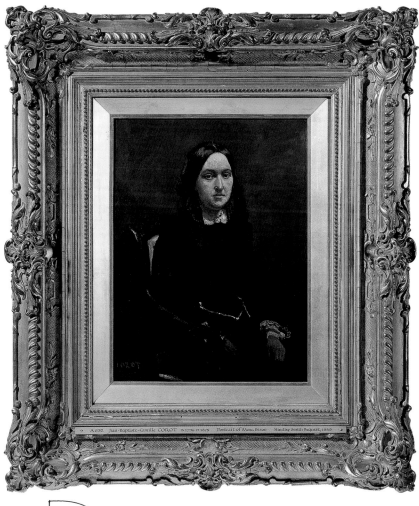

Scale 1:2

53

22 England *c*.1840

Ford Madox Brown (1821–1893)
Mrs Madox 1840
A936a; WA1960.53
Presented by Francis Falconer Madan, 1960

Lime(?) water-gilt
Sight size: 10 × 8.5 cm; moulding size: 2.3 × 2.5
cm; picture size: 10 × 8 cm

This single oval frame is ornamented only with a ges-
soed and water-gilt reeded moulding. The moulding
profile is made up of a succession of reeds on a broad
cushion providing a curved surface. The shape of the
frame reinforces that of the painting, recognising the
brushwork with the narrow reeds and gradations of
tone. The whole design is of sufficient weight to enable
this small painting, essentially a miniature, to be hung
beside larger paintings.

Though derived from patterns which were far
more complicated, the source of this frame could well
have been French Louis XVI-revival miniature frames.
These were made of gilt metal and often used clusters of
reeds bound by ribbons or twisted acanthus leaves.
Many examples may be seen in the Wallace Collection,
London. Later this type of moulding was used by Degas
and Whistler, with the latter preferring an oil-gilt finish
directly on the oak, which provided a particular texture
appropriate for his atmospheric paintings.

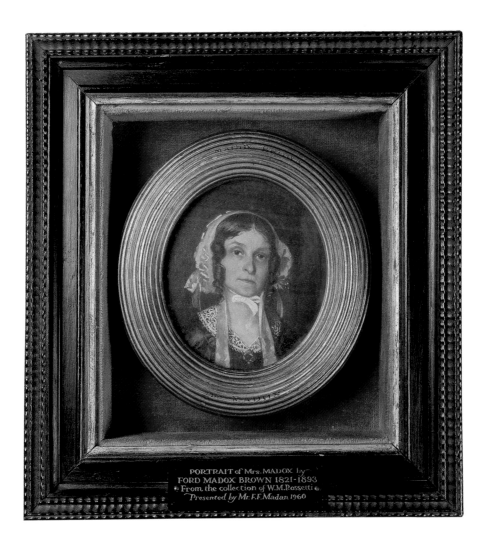

PORTRAIT of Mrs. MADOX by
FORD MADOX BROWN 1821-1893
From the collection of W.M.Rossetti
Presented by Mr. F.F.Madan 1960

Scale 1:2

23 England c.1853

Ford Madox Brown (1821–93)
The Seeds and Fruits of English Poetry 1845–53
A360; WA1920.3
Presented by Mrs Florence Weldon, 1920

Pine, carved and gilt
Sight size: 32.5 × 45.5 cm; moulding size: 4.8 × 8.6 cm; picture size: 34 × 46 cm

Inspired by the competition for fresco decorations on themes of English history in the Palace of Westminster, Ford Madox Brown planned a grand composition in this oil-sketch, in the manner of a secular altarpiece. An inscription on the sketch records that it was designed in Rome in 1845 and painted in Hampstead in 1853. Brown had travelled to Italy in 1845, where he was inspired by early Italian paintings and types of framings. He met with some of the Nazarenes, a group of German artists who advocated a return to the pure religious sentiment of Gothic art, and they too were interested in emulating the framings and settings of medieval and early Renaissance pictures. Brown's new ideas are reflected in this sketch and its frame.

The frame appears to be the original one, designed by the artist. The painting is divided into three monochrome Gothic arches of tracery intertwined with gilt vines, with figures of English poetry below. An inscription in a neo-medieval script on the *slip* of the frame identifies the poets depicted. The backgrounds of the two outer arches have gold grounds, and the use of gold in the painting (particularly for the bunches of grapes) sets up a visual relationship with the frame. The motif of the vine is echoed in the carved frame, where the ornament emanates from the top and base centres. Acorns are also included in the ornament, probably to suggest the seed of poetry in England. However, this rendition of the vine is stylistically derived from a type of frame design in Venice around 1600 which was revived with other North Italian patterns in England in the middle of the nineteenth century.

Scale 1:2

57

Charles Allston Collins (1828–1873)
Convent Thoughts 1851
A273; WA1894.10
Bequeathed by Mrs Thomas Combe, 1894

Pine, water-gilt, composition
Sight size: 82.5 × 58 cm; moulding size: 5 × 8.7
cm; picture size: 84 × 59 cm

John Everett Millais designed this frame in 1851 and painted the inscription *Sicut Lilium* (*As the lily [among thorns]*, from the *Song of Solomon*), a traditional reference to the Virgin Mary. The overtly Catholic iconography of the painting, accentuated by its framing, was highly controversial at the time. Millais wrote to Thomas Combe 'I have designed a frame for Charles's painting of "Lilies" which, I expect, will be acknowledged to be the best frame in England.' His own painting, *The Return of the Dove to the Ark* (Ashmolean Museum, A271), is framed in similar taste with its symbolic garland of olive leaves. Millais seems to have persuaded Combe to hang this and *Convent Thoughts* on either side of Holman Hunt's *A Converted British Family* (A265), making a kind of triptych in which the designs of the frames had an important role in the overall aspect.

The moulding of the frame is very simple, flat with hollows on the *sight edge* and *back edge*, the sight edge forming an arch. Applied to this are two high relief waterlilies made of *composition*. The ornament is illustrative and, though naturalistic, deliberately simplified: while it does not enhance the illusionistic space of the painting, it provides both a three-dimensional equivalent of one of the motifs within the painting, and a comment on the inscription. There are distinct divisions of matt and burnished gilding and the inscription is painted in neo-medieval style.

Ornament rendered in this manner is very similar in appearance to North Italian seventeenth-century stucco work. The summarised moulding profile shows that, like nos. 23 and 26, all of these mouldings are seventeenth-century Italian in origin.

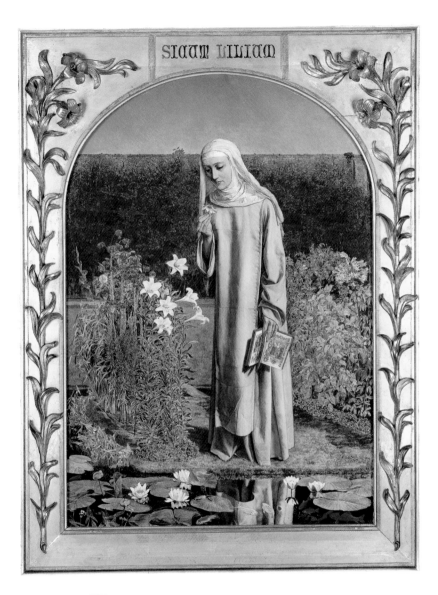

Burnished
Matt

Scale 1:2

25 England c.1877

William Holman Hunt (1827–1910)
Plain of Esdraelon from the Heights above
Nazareth 1870–77
A270; WA1894.6
Bequeathed by Mrs Thomas Combe, 1894

Pine, water-gilt, composition
Sight size: 41.5 × 75 cm; moulding size: 5 × 13.5
cm; picture size: 41 × 75 cm

Holman Hunt designed this frame for his painting in 1877. Made by Foord and Dickinson of 90 Wardour Street, London, who were the principal frame-makers for the Pre-Raphaelites, it includes palmette and vine ornament at the centres and corners. The inscription (from *Henry IV Part I*, Act 1, 24–7) reads: *In these holy fields/ over whose acres walked those blessed feet/ which fourteen hundred years ago were nail'd/ for our advantage on the bitter cross.* Hunt was deliberately recalling the fact that many fifteenth-century Italian and Flemish paintings carried inscriptions on their frames. Moreover, the application of circular ornament was probably derived from early Italian ('pre-Raphaelite') frames, for example that of the *Ruccellai Madonna* 1285 by Duccio, in the Uffizi, Florence.

Over a long career, Hunt designed a variety of frames, based on wide-ranging sources, often with symbolic ornament and always with motifs appropriate to the subject. Here, the vines refer to the local landscape and, symbolically, to the wine of the Eucharist, the blood of Christ. The palmette is a motif of Islamic origin, as is the interlaced pattern, hence the ornament carries echoes of the Holy Land. This concern with providing suitable frames for individual paintings was part of a reaction against the indiscriminate revival of historical styles in the Victorian age. The use of particular ornamental devices on a generally available moulding suggests that no particular proportional relationship to the painting was planned, which leaves the design somewhat weak. The loosely painted border, echoing the design of the interlaced band, has been applied with artists' oil paints onto a standard gilt *slip* of the time, and was probably painted by Hunt, together with the inscription giving the title of the picture.

A similar example of a shallow gilt frame with turned centre and corner ornament may be seen on *Proserpina* 1873–1877 by Dante Gabriel Rossetti in a private collection.*

*See E. Mendgen et al, *In Perfect Harmony. Picture + Frame, 1850–1920*, Amsterdam and Vienna 1995, cat. 48

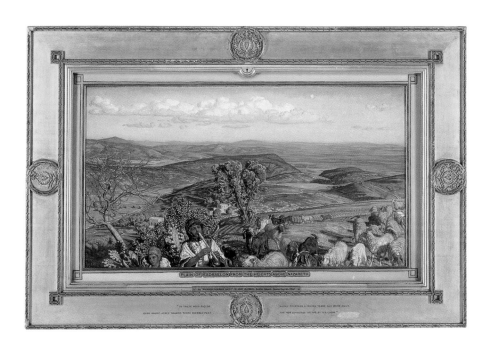

Scale 1:2

Frederick Lord Leighton (1830–1896)
Acme and Septimius (Catullus XIV)
A1089; WA1978.7
Bequeathed by R.S. Newall F.S.A., 1978

Pine, carved, gilt and composition
Sight size: 96 cm diameter; moulding size: 6 ×
16.7 cm; picture size: 99 × 99 cm

By the 1870s many artists were designing their own frames, following upon the example of the Pre-Raphaelites. Leighton was interested in classical frame types, often with archaeologically-correct detail, including *aedicular* frames that evoke the portals of Greek temples. However his frames were intended to complement the subjects and compositions of his paintings, and this circular canvas would not have suited an aedicular frame. Here the composition involves a series of interlocking curves, reinforced by the circular format. Almost certainly designed by Leighton, this square frame with a circular spandrel is in excellent condition. The spandrel has a fifteenth-century style hollow *sight edge* and four turned roundels with flowing and interlaced laurel leaves. The rhythm and refinement of the ornament in these roundels echoes the tender mood of the embracing couple. The moulding of the frame begins at the inner edge with an *astragal* and hollow profile revived from early fifteenth-century Flemish altarpieces. It then rises to a broad shallow astragal of fruit and leaves, made of *composition*. The back edge is a falling hollow with sharp narrow flutes which relate the outer edge of the frame to the wall. The fruit and flower motifs on the broad moulding of the frame deliberately acknowledge the richly detailed leaves, fruit and flowers within the painting. The fluting of the back edge provides an appropriate reference to motifs in antique architectural decoration, complementing the classical subject-matter.

The use of early Flemish elements to compose a 'neo-classical' frame suggests a solemnity and pathos not often found in later styles. As with other frames found on paintings by Lord Leighton, this is made to an unusually high standard; another good example is on *The Last Watch of Hero of 1877*, Manchester City Art Gallery.

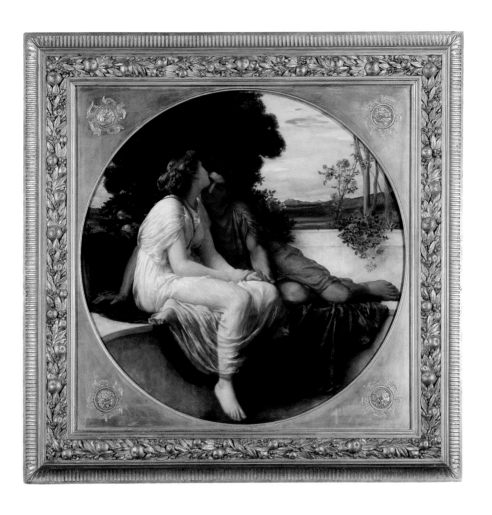

Scale 1:2

63

27 France c.1880

Eugène Boudin (1824–1898)
The Estuary
A633; WA1940.1.15
Bequeathed by Frank Hindley Smith, 1939

Pine, plaster and gesso, water-gilt
Sight size: 20 × 31 cm; moulding size: 6.6 × 12 cm; picture size: 21 × 32 cm

This is an example of a 'Barbizon Frame,' a revival of a late Louis XIII style of pattern of c.1650, which was named after the Barbizon school of artists, whose paintings are frequently framed in this style. The ornament is cast in plaster which creates a static type of ornament without undercuts. The top edge is a typical alternating acanthus leaf and husk and the gilding is metallic in character.

The relationship of the frame to the painting is very loose, however, its function is to provide a rich surround redolent of historical weight and authority, allowing the small, delicate painting to hold its own on a crowded wall. The Barbizon pattern could be produced in all sizes, and was well-suited to landscapes since the rhythm of the profile enhances an effect of recession. This type of framing was popular in the annual Salon exhibitions in Paris, where a great variety of pictures were hung in heavily ornate gilt frames, if anything suggesting the wider Baroque framing of seventeenth-century Italy.

The Barbizon style of frame was used by Henri-Joseph Harpignies (1819–1916) throughout much of his career, for example on *Autumn Evening* of 1894 and *Les Oliviers à Menton* of 1907, both in the National Gallery (NG 6325 and 3808). A fine example in the Ashmolean may be seen on *The Banks of a Stream* by Gustave Courbet (A470).

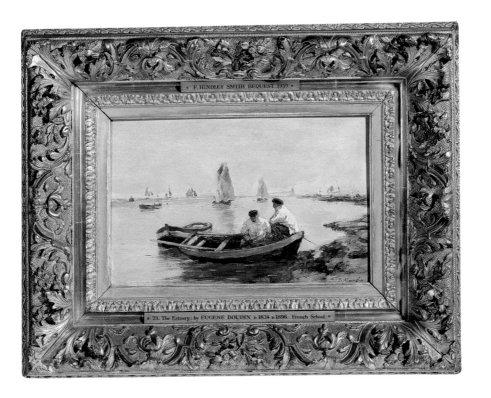

Scale 1:2

65

28 Rome c.1700

Camille Pissarro (1830–1903)
Ferme à Montfoucault: Effet de Neige 1876
A822; WA1951.225.2
Presented by the Pissarro Family, 1952

Poplar, carved and gilt
Sight size: 52x 63.5 cm; moulding size: 5.2 × 11.1
cm; picture size: 54 × 65 cm

Here, a Salvator Rosa frame has been re-worked to frame an Impressionist painting. It is an early Roman example carved in poplar and with the characteristic acanthus leaf and shell behind the sight edge moulding. Later the gilding was painted with bronze colour and a thick grey paint washed over it. The bronze has now become dark green. This pattern provides a subdued and articulated surround with lateral diversions in the carving which complement the brushwork. The greyish-green tone now accentuates the impression of a winter light on snow. As discussed under no.19, the Salvator Rosa pattern took various forms with this one, when in its original form, being one of the more significant. The emergence of this formal arrangement of ornament still retains the underlying rhythm of classical ornament. A larger version may be seen on Marchese Pallavicini and the Artist of 1705 by Carlo Maratta, Stourhead, Wiltshire, (National Trust).

Impressionist artists reacted against the aesthetics of academic art, and against the way in which paintings were displayed in heavily ornate frames, cheek by jowl, in the prestigious Salon exhibitions. In their independent group shows, these artists experimented with different types of framings, including simple frames that would not compete with the painting for attention. Pissarro exhibited his work in white frames in 1877, on the basis that white could enhance the intensity of the colours in his pictures, and he experimented with coloured frames. He also designed a frame type that was a compromise between the avant-garde and the traditional, where the painting would be bordered by a white band within an oak frame that had a gilded laurel wreath border. In the 1880s he ordered frames to be made in carefully nuanced shades of greyish white, complementing the tones within the paintings. By the 1890s he was interested in gilded frames, noting that the tones of his paintings could be heightened by the warmth of the gilding. Another example of an old master frame re-used perhaps by Pissarro himself is the Louis XVI-style frame of the late eighteenth century on Sunset at Eragny of 1902 in the Ashmolean (A795).

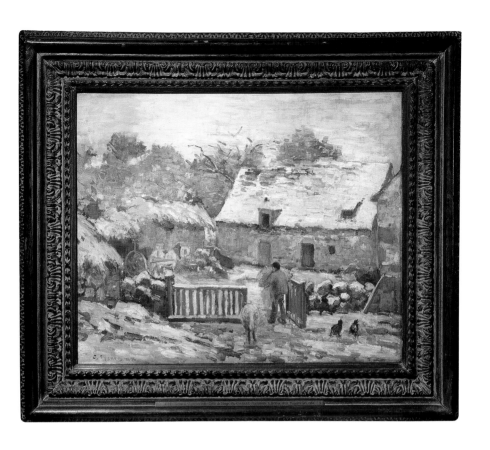

Scale 1:2

67

29 France – Provincial style of *c*.1730, made early twentieth century

Walter Richard Sickert (1860–1942)
Ennui 1917–1918
A618a; WA1940.1.92
Bequeathed by Frank Hindley Smith, 1939
© Estate of Walter R. Sickert 2002. All Rights
Reserved, DACS

Oak, carved and gilt
Sight size: 74.5 × 54 cm; picture size: 76.6 × 56.5
cm

In the late nineteenth century, dealers in France often framed Impressionist paintings with seventeenth- and eighteenth-century French frames. The suitability of these frames was partly based on the example of early eighteenth-century framings of sketchily-painted compositions by Watteau, Greuze, Boucher and others. Such historical frames complemented French interiors, merging with the existing decoration of a room. Moreover old frames were readily available at that time and relatively cheap. Re-using these frames made it possible to integrate Impressionist paintings into existing collections. Sickert was influenced by Impressionist and Post-Impressionist painting and the frame may well have been chosen for the picture in keeping with French framing practice. In any case, the character of the painting, with its ragged brushwork, strong forms and sharp tonal contrasts, stands well with a Régence-style frame.

The articulation of the moulding profile, which gradually falls towards the painting, and the organised gestures of the ornament acknowledge the structure of brushwork without disturbing the tension of the subject matter, as swept *top edge* rails or asymmetric corners of Louis XV frames undoubtedly would have done. Whilst based on a provincial Régence pattern of *c*.1730, this frame is later in date because of the interpretation of the moulding profile: the *sight edge* is weak and summary.

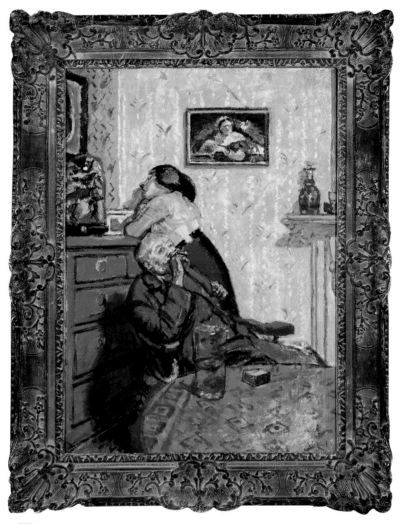

Scale 1:2

30 England 1907, based on an Italian seventeenth-century type

Walter Richard Sickert (1860–1942)
Gaieté Montparnasse: Dernière Galerie de Gauche 1907
A1230; WA2001.28
Presented by The Christopher Sands Trust, 2001
© Estate of Walter R.Sickert 2002. All Rights Reserved, DACS

Pine, plaster, water-gilt
Sight size: 59.5 × 48.5 cm; moulding size: 4.8 × 10.1 cm; picture size: 61.3 × 50.6 cm

Probably the original frame chosen for the picture, this is derived from a South Italian pattern of *c*.1640. The closest example of such patterns appear to be stucco ceiling mouldings probably in turn derived from antique architectural *ogee* mouldings which carried lotus leaves. The frame was economically cast in plaster in imitation of carved and *gessoed* ornament. The corner cartouches are strongly designed with repeating acanthus *cabochon* ornament between the strap work which is particularly bold. The whole frame is rather theatrically set out in blocks of ornament with the reddish bolus (the ground beneath the gold) exposed at regular intervals. This relates well to the Rubenesque red underpainting visible on the canvas. Thus the frame, with its emphasis on strong patterning, acknowledges both the vigorous rhythms of the picture, with its dramatic viewpoint and sweeping curves, and the ornate qualities of the painted theatre itself. Comparable effects of framing were sought by John Singer Sargent and William Orpen in the 1900s, and by Philip de Laszlo in the 1910s and 1920s.

Scale 1:2

31 England 1910–13

David Bomberg (1890–1957)
Procession c.1912–14
A1120; WA1981.604
Presented by the artist's sister & her husband,
through the Contemporary Art Society, in mem-
ory of the artist, 1981

Three-ply board, oak, varnish
Sight size: 28.5 × 68.5 cm; moulding size: 1.1 ×
3.5 cm; picture size: 28.9 × 68.8 cm

One of the simplest frames possible, this strip of oak is
attached as a framing device to a piece of three-ply
board which has paper laid on it as a support for the
painting. The oak is merely treated with a dark varnish.
The proportions are minimal but the strength and
pared-down simplicity of the framing border is suitable
for the Vorticist procession of massive, block-like fig-
ures. Essentially this is a panel with an integral frame,
designed in such a way that no other frame need be
applied. Some early twentieth-century artists regarded
picture frames – particularly the traditional gallery
frame – as repressive elements, encroaching upon the
painted surface or restricting its space. Others saw the
frame as a symbol of high art, or as allied to illusionistic
painting, denoting a window-like aperture. From either
perspective, the frame was inimical to the aims of the
new art, whether abstract or demotic.

This most basic moulding profile is a square step,
or *taenia* in classical architecture, and has frequently
appeared since the thirteenth century. It can be seen in
late fifteenth-century Italian *aedicular* frames, late six-
teenth-century *luminolegno* frames, Louis XVI, Direc-
toire and Empire frames. This moulding element has a
measured, steadying effect on a painted composition.
The frame on *Still-life, 1945* by Ben Nicholson
(1894–1982) in the Ashmolean Museum (A1202) also
applies this effect.

Scale 1:2

32 England c.1928

Glyn Warren Philpot R.A. (1884–1937)
Gabrielle and Rosemary 1928
A1023a; WA1966.28
Presented by Gabrielle Cross, the artist's niece, 1966

Pine, plaster, white paint, oil, gilt
Sight size: 141 × 110.5 cm; moulding size: 7.6 × 9.7 cm; picture size: 143 × 112.2 cm

This appears to be the original frame for this double portrait, which remained in the artist's family until presented to the museum; a label on the reverse reads 'Chapman Brothers, 241 Kings Road, Chelsea'. The frame was finished in white and gold, and later painted with bronze, which has now darkened. The moulding and ornament are possibly derived from Veneto stucco mouldings of the late sixteenth century or early seventeenth centuries. However, this strong moulding with shallow smoothed ornament suits the controlled but considered pose of the two sisters who are drawn with great clarity. Although narrow for the size of the painting, the frame, with its considerable depth and undercut, suggests a grandeur by the inferred shadows.

White has been used sporadically for frames since the fifteenth century, its success dependant on the strength of the moulding profile and ornament (see no.33). White and gold stucco-work was a common feature of sixteenth and seventeenth-century Italian palace decoration, as in the stucco decoration of the Palazzo Farnese, Rome designed by Annibale Carracci in the late 1590s. At Ham House, Richmond, the white and gold withdrawing room designed by Franz Cleyn is recorded in an inventory of 1637. This was probably inspired by white marble with gilt bronze appliqué. The combination of white and gold provided a light yet luxurious effect in interior decoration or framing devices.

Scale 1:2

75

33 England c.1925–1930

Ivon Hitchens (1893–1979)
A Border Day 1925
A1146; WA1987.37
Bequeathed by Mrs Mary Freeman, née Short,
1987

Pine, white oil paint
Sight size: 512.5 × 59.5 cm; moulding size: 4.3 ×
11.8 cm; picture size: 56.4 × 61 cm

This loosely-painted abstract view from a window sug-
gests depth and reflected light. The frame in a simple
way also suggests depth without imposing a controlled
sense of space. The white finish lightens the colours in
the painting where gold would have made them too
complicated. This finishing may have been influenced by
Ben Nicholson with whom Hitchens was staying when
he painted this picture. The frame is composed of pieces
of readymade *architrave* probably purchased from a
builders' merchant and it appears to have been made by
the artist. The mouldings have been carefully arranged
so as to lead the viewer's eye into the picture space, with
its strong sense of recession.

White frames have been made since the fifteenth
century and in the late nineteenth century were used by
Impressionist and post-Impressionist artists, particular-
ly by Degas, as in his *Resting Dancer* of 1879 (private col-
lection), and Pissarro (see under no.28) although few of
their original frames survive. In the 1880s, white frames
were a symbol of the avant-garde. In his painting of
Models of 1888 (Barnes Foundation Museum, Merion),
Georges Seurat depicted his celebrated *La Grande Jatte*
hanging on the studio wall in a broad white frame. Seu-
rat was especially interested in the colour theories of
Michel-Eugène Chevreul, whose optical experiments
showed that putting white alongside a colour height-
ened its tone. In England, Whistler explored the aesthet-
ic effects of white frames in the early and mid 1880s,
while artists such as William Orpen and Augustus John
employed white frames in the 1910s and 1920s. By the
time Hitchens painted *A Border Day*, white or coloured
frames were commonly used, evoking modernity and
experimentation and avoiding the more traditional
associations of the gilded frame.

Scale 1:2

Georges Braque (1882–1963)
The Tobacco Packet (Le Paquet de Tabac) 1931
A639; WA1940.1.21
Bequeathed by Frank Hindley Smith, 1939
© ADAGP, Paris and DACS, London 2002

Pine, water-gilt
Sight size: 23.5 × 32.4 cm; moulding size: 4.5 ×
12 cm; picture size: 24 × 35 cm

This bold, uncomplicated cassetta is well suited to the small still-life composition it frames. The ornament on the sight edge is more than enough and the remaining blank moulding of slightly undulating gesso and gold recognises the broader areas of painting in the composition. The remains of a darkened bronze paint which could be original to the framing can be seen on the frieze. The choice of a wide frame suggests that this is an unusually small painting for this artist, with the frame evoking the larger scale usually encountered.

Interestingly, Spanish sixteenth- and seventeenth-century frames have often been chosen for Cubist paintings. Perhaps their bold simplicity brings together these essentially fragmented compositions, suggesting a greater sense of substance. Both Picasso and Braque owned antique frames, as can be seen from photographs of their studios, and Braque seems to have been interested in the effects that different types of framing could achieve. In Braque's still-life, the sonorous tones and intensity of approach recall Spanish still-life paintings by masters such as Zurbarán and Meléndez, making the choice of frame particularly appropriate.

The cassetta first appeared in Spain in the middle of the sixteenth century, much later than elsewhere in Europe. This was because Gothic ornament predominated until the introduction of the aedicular frame from which the cassetta is derived.

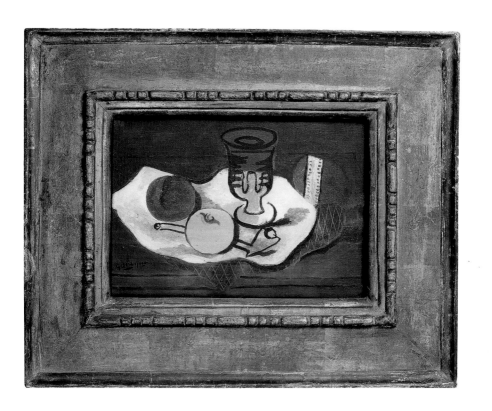

Scale 1:2

Glossary

Aedicular: frame based on the forms of classical architecture, consisting of an entablature supported by pilasters on a base.
Altarpiece: often aedicular frame for a religious painting placed on or above an altar.
Architrave: lower moulding of an entablature.
Astragal: half round convex moulding.
Auricular: meaning 'of the ear': ornament derived from organic, fleshy and marine forms.
Back edge: moulding furthest from the painting or framed object.
Back frame: basic wooden structure that supports the mouldings and ornament.
Bolus: a coloured clay used as the underlayer for gold leaf in gilding.
Cabochon: an egg or boss in a circular surround.
Canaletto: Louis XIV-derived pattern made in Venice and associated with the painter of that name.
Cartapesta: Italian fifteenth to seventeenth-century paper and glue mixture pressed into moulds.
Cassetta: simple box-like frame with a raised moulding on either side of a frieze.
Cauliculus: a sheath of acanthus or leaves around a volute.
Composition: used from the eighteenth century onwards: mouldable material made of whiting, glue, oil and resin, also known as compo.
Cornice: upper moulding of an entablature.
Ebonised: painted or stained and polished so as to look like ebony.
Engaged: frame fixed permanently to a painting.
Entablature: upper horizontal mouldings of an aedicular or classical structure with three parts: Cornice, Frieze and Architrave.
Fresco: wallpainting of pigment set in wet plaster.
Frieze: flat trough between two mouldings
Fronton: French ornament projection at the top of a frame.
Gesso: slated chalk mixed with animal glue (often rabbit skin) as a ground for gilding.
Kwabwerk: fleshy 'lobe work' of Dutch auricular frames.
Luminolegno: Italian parcel-gilt walnut ornament; a type of selective highlighting.
Oculus: circular centre of an ornament.
Ogee: 's' section moulding where a concavity runs into a convexity.

Oil-gilt: where the gold leaf is adhered by oil varnish.
Ovolo: quarter round convex moulding.
Panel: wooden support for painting, often poplar or oak.
Parcel-gilt: gilt highlights against a plain ground, deriving from partly gilt silver plate.
Pastiglia: Italian raised ornament made by trailing gesso from a brush.
Patera: symmetrical floral ornament with petals surrounding a circular centre.
Polyptych: an altarpiece consisting of several panels, often in tiers.
Rebate: recess beneath the sight edge of a frame intended to receive the painting or framed object.
Reparé: embellishment of the gesso in preparation for gilding, particularly in France.
Reredos: Spanish multi-tiered polyptych.
Rocaille: shell-derived ornament characteristic of the Rococo style.
Sansovino: late sixteenth to seventeenth-century frame style, named after the architect and sculptor Jacopo Sansovino, characterised by interlaced volutes and scrolls.
Sgraffito: gilt ornament created by scratching through paint to reveal the gold beneath.
Shell Gold: gilt ornament painted with gold powder ground in gum arabic, so-called because the powder was kept in shells.
Sight edge: moulding nearest to the painting or framed object.
Slip: a flat or bevelled band inserted in the rebate; when a picture is glazed, used to separate the glass from the painting.
Stretcher: wooden frame which supports and stretches a canvas.
Tabernacle: frame employing architectonic structural and decorative elements; it takes its name from a liturgical furnishing.
Taenia: flat, raised moulding.
Top edge: moulding nearest to the viewer, projecting farthest from the back frame.
Volute: large terminating taenia which spirals around an oculus.
Water-gilt: where the gilding with thin leaves of gold onto a layer of bolus has been bound with a water-based adhesive.

Bibliography

Atterbury P. and Wainwright C., *Pugin: A Gothic Passion*, New Haven and London 1994.
Brettell R.R. and Starling S., *The Art of the Edge: European Picture Frames 1300–1900*, Chicago 1986.
Cannon-Brookes P., 'Elias Ashmole, Grinling Gibbons and Three Picture Frames', *Museum Management and Curatorship*, Vol.18, No.2, 1999, pp.183–89.
Grimm C., *The Book of Picture Frames*, New York 1981 (translated from the original German edition of 1978).
Mendgen E. et al, *In Perfect Harmony. Picture + Frame, 1850–1920*, Van Gogh Museum, Amsterdam and Kunstforum, Vienna 1995.
Mitchell P. and Roberts L., *A History of European Picture Frames*, London 1996.
Newbery, T. 'Towards an agreed nomenclature for Italian picture frames', *The International Journal of Museum Management* IV, 1985, pp.119–28.
Newbery T., Bisacca G., and Kanter L., *Italian Renaissance Frames*, New York 1990.
Penny N., *Frames*, National Gallery, London 1997.
Sabatelli F., *La cornice italiana dal Rinascimento al Neoclassico*, Milan 1992.
Simon J., *The Art of the Picture Frame. Artists, Patrons and the Framing of Portraits in Britain*, London 1996.
Taylor, G., 'Frames on the Tradescant/ Ashmole Paintings', in *Tradescant's Rarities. Essays on the Foundation of the Ashmolean Museum*, ed. A. MacGregor, Oxford 1983, pp.327–29.
Thiel P.J.J. van and C.J. de Bruyn Kops, *Framing in the Golden Age. Picture and Frame in 17th-Century Holland*, Zwolle 1995